Creative Kinetics

MAKING MECHANICAL MARVELS IN WOOD

Rodney Frost

Photography by Leanne Fuchs

STERLING

New York / London
www.sterlingpublishing.com

STERLING and the distinctive Sterling logo are registered
trademarks of Sterling Publishing Co., Inc.

Library of Congress Cataloging-in-Publication Data
Frost, Rodney.
 Creative kinetics : making mechanical marvels in wood / Rodney Frost ;
Photography by Leanne Fuchs.
 p. cm.
 Includes index.
 ISBN-13: 978-1-4027-3223-2
 ISBN-10: 1-4027-3223-6
 1. Woodwork. 2. Wooden toy making. 3. Kinetic art. I. Title.

TT180.F8 2007
684'.08—dc22 2006100969

10 9 8 7 6 5 4 3 2 1

Published by Sterling Publishing Co., Inc.
387 Park Avenue South, New York, NY 10016
© 2008 by Rodney Frost
Distributed in Canada by Sterling Publishing
℅ Canadian Manda Group, 165 Dufferin Street
Toronto, Ontario, Canada M6K 3H6
Distributed in the United Kingdom by GMC Distribution Services,
Castle Place, 166 High Street, Lewes, East Sussex, England BN7 1XU
Distributed in Australia by Capricorn Link (Australia) Pty. Ltd.
P.O. Box 704, Windsor, NSW 2756, Australia

Interior Book Design and Layout: Dutton & Sherman Design
Photography: Leanne Fuchs

Sterling ISBN-13: 978-1-4027-3223-2
 ISBN-10: 1-4027-3223-6

For information about custom editions, special sales, premium and
corporate purchases, please contact Sterling Special Sales
Department at 800-805-5489 or specialsales@sterlingpublishing.com

CONTENTS

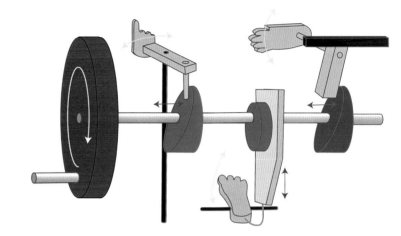

Using Mechanics Creatively 51

Making Mechanical Marvels

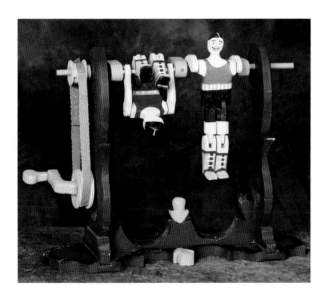

Kinetic Art

Can you ride a bike? Can you swim? How did you learn? Perhaps you saw other people doing it. Maybe you looked in a book, but what happened next? Possibly you tried it yourself, saw what happened, and then tried it again a little differently. There's a lot of this way of doing things in *Creative Kinetics*, a book to start you off doing art that moves.

Art that moves is called *kinetic art*. A painting of a running horse is not kinetic art, but a painting of a running horse, with legs that actually move, is.

Human beings and all living creatures notice change. Movement is change. Noticing change is a discovery. We enjoy pleasant surprises; they bring a smile to our faces and make us laugh.

I like doing kinetic art because people react to it. If you make a painting of a rock and a tree by the lake, they may say, "That's nice" or "I like the colors." If you make a model of a tree and a rock by the lake, with the waves moving and maybe a boat going by, people will smile or laugh. Did you know that when people discover something, they laugh?

Art that moves gets people laughing—especially the wiggling eyebrows, talking heads, and other pleasant discoveries. Movement, change, discovery—that's what we mean by kinetic art!

What's in This Book

We'll start with some simple projects that use the air around us to get them going. Then I'll suggest some other ways of making art that moves using other kinds of power. You'll learn about cams and cogs,

levers and cranks, and how these things can help you build your own kinetic art machines. Propellers, jumping jacks, and moving-picture machines are in here too.

Some of the things to make in *Creative Kinetics* have detailed instructions, but mostly I'll give you basic information and then you can try it for yourself—just like learning how to swim.

In this book, you'll find some kinetic art done by artists who work at it all the time. Their work is exciting, fun, and sometimes mysterious, but they rarely got it right the first time. You'll find out how these kinetic artists solved some of their problems of movement—how Peter Dennis gets his cutout soldiers to march in a circle, how Kevin Titzer has Madame Ruby tell us our fortune, and how Craig Bloodgood uses gravity to move a ball. Every one of these artists has gotten stumped at some point, yet they all kept trying until they got those wheels to go around and the levers to tweak the art into action.

You don't need much technical experience to get started in kinetic art, and you don't need to make a big investment either. We can make a weather vane from nothing more than a piece of paper, a pin, and a drinking straw; we can make wild propellers from tuna fish cans.

This book has plenty of ideas to get you started doing kinetic art. There are also sections on planning (and when not to plan); handy tips on materials, tools, and skills; and even thoughts on how to be an artist.

What's *Not* in This Book

Most how-to books have an entire section on what tools you need. Generally there is a big list of equipment that you must have before you even begin. Not this book! I never even bother with those lists anymore, partly because I'm experienced, but mainly because often you need only one or two things from the vast list for the things you want to make. So we'll figure out what you want to make and then find out what you need from the tools department. I will tell you as we go along what might be handy to use, and I'll suggest some other ways of doing things too. So, no exhaustive tools list!

Why does every nonfiction book have to start with a section on the history of whatever it is the book is about? In this book, there's no history section either. If some historical fact is relevant (and I know about it), it will be mentioned. The history and development of what became kinetic art is interesting, though. The term *kinetic art* is hard to find even in art books. Look for *automata* and *toys*. Search the Internet if you have access to it, but don't worry if you don't. I don't, and I get along fine just as I did before it was invented. I say nuts to virtual—be practical!

Now let's get started.

GETTING THINGS TO MOVE

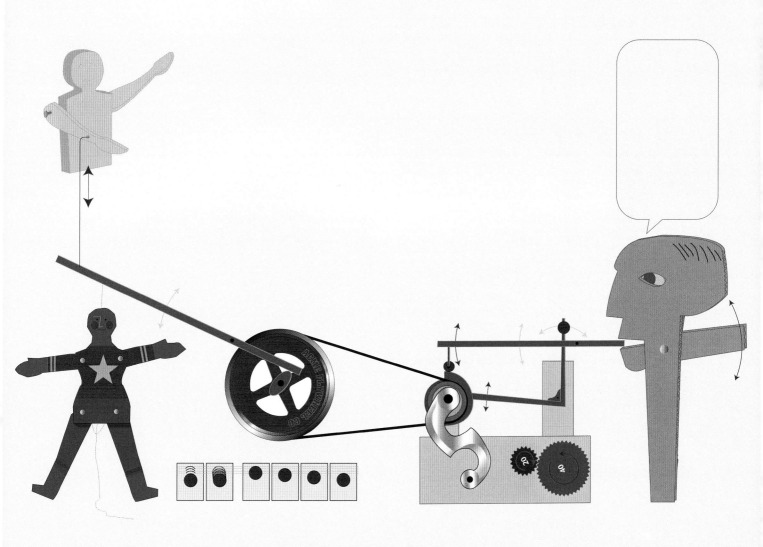

Weathercock

Next spring Wayne Mumford will be building this large weather vane into his new cupola.

Once we all relied on the weather for just about everything. We were close to nature. Today, we are still close to nature, but we don't know much about it. As the author Ambrose Bierce said, we can invent machines, but let's not imagine that we have invented civilization. We will be making and inventing some machines in this book. The nicest ones are those that use nature as their power, like this weathercock. Weather vanes bring us closer to the natural cycles, which is important for our well-being, as well as knowledge.

We are going to start with something that may seem a bit complicated but is really quite simple and useful. Don't be daunted by this weathercock. Look at the pictures and see how it's made. Don't let your mind say, "Oh, that's too difficult." Just look at the pictures, imagine someone else making it, and then come back to it later.

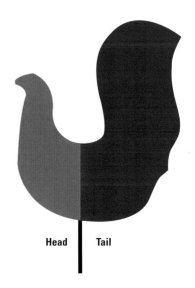

Head | **Tail**

Making the Weathercock

Copy the picture below. Use a photocopy machine, or square it up, or just guess. The important thing to notice is that the area of the **tail** is larger than the **head**. This will make it face into the wind. It will tell us where the wind is coming from. (These instructions continue on page 6.)

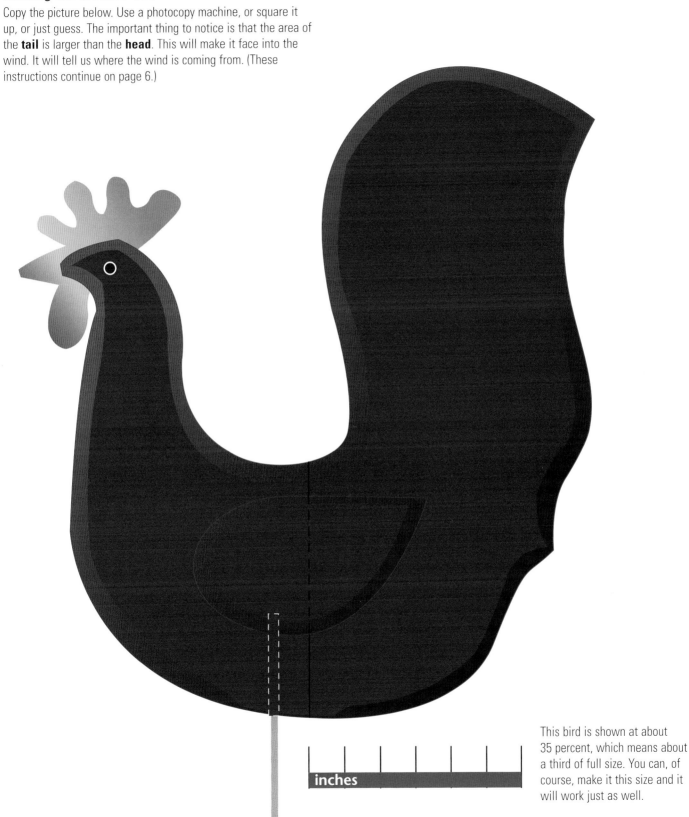

inches

This bird is shown at about 35 percent, which means about a third of full size. You can, of course, make it this size and it will work just as well.

Why Is It a *Weather* Vane?

Once, not so long ago, everyone knew what the weather was going to be by watching the way the air moved. Some people can still do this.

There were sayings people used, such as, "When the wind is from the south, then the rain is in its mouth." This means when the wind blows from the south it is going to rain.

Years ago most people had to work out of doors. When working in the weather, growing plants and raising animals or sailing lakes and oceans, it's very important to know if it will be dry, rainy, or windy.

Barns and churches had a device on the topmost point to tell everyone what the wind was doing—not just the direction it was blowing but also how it was changing direction. People had to look often, so they made these devices interesting, fanciful, and familiar things, such as roosters, fish and mermaids, and horses.

Cutting Curves

Cutting curves can be done in many ways. You can use any of these tools. These pictures and notes tell you what I find useful. I'm not going to tell you how to use these tools, as there are a great many books that can tell you that in detail.

Fretsaw The fretsaw is made for cutting thin wood (less than ¼ inch, but I find it good for up to about ½ inch). It uses thin blades with small teeth for tight curves.

Fretsaws are not so common nowadays, but sometimes you can find them cheap at yard sales.

Coping Saw This is a fairly common saw. It's available just about anywhere.

The trick that most people don't know is that the teeth face down (toward you). You pull it through the wood, you don't push it!

Jigsaw The jigsaw is noisy but safe, if you don't put your hand underneath when operating!

Blades come in smooth-cut to totally rugged big-tooth. Get a smooth-cut. Make sure nothing valuable is under the jigsaw when cutting (I speak from sad experience).

Scroll Saw Later on, when you get into this stuff, you'll want one of these. The scroll saw is very safe and nice to use.

The blades come with pins on the end or plain. Get the plain kind; the blades are much easier to use. Unfortunately, as with all things good, sensible, and efficient, the manufacturers feel they must make "improvements" and so plain-blade scroll saws are hard to find! Keep searching, though.

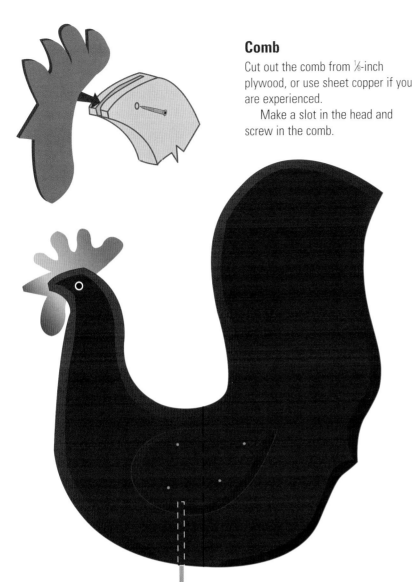

Comb

Cut out the comb from ⅛-inch plywood, or use sheet copper if you are experienced.

Make a slot in the head and screw in the comb.

paper pattern

paper pattern

Rod

A ¼-inch bar is good for this. In the bird, it's loose. In the ball, it's tight.

Cut around your copy of the bird from page 5 to make a template. Put the template on the wood. Mark and cut. Glue the two parts of the bird together.

Cut out the wings, and glue and nail them into position. Notice that the wings are not just for decoration but also help to hold the two body parts together. Make sure the nails are on both sides. Drill a hole up into the body for the rod. Make the hole a little larger in diameter than the rod.

Wood

Use 1-inch pine for this vane (1-inch pine is ¾ inch thick) or anything else you think will work if pine is not available.

The ball is a fence ball. You could use a plain piece of wood and it would look good too. The screw thing is called a *dowel screw* or *hanger bolt* (it has a thread on both ends).

2 Wind Toys

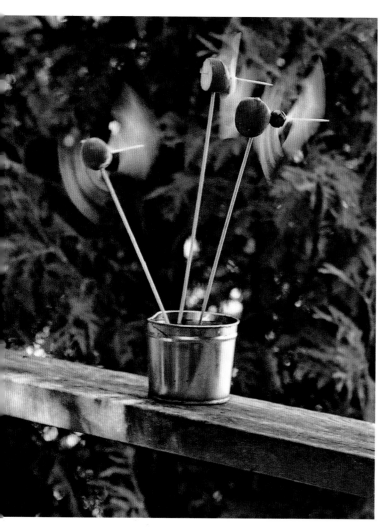

Air moves all the time. Feel the breeze on your cheek or see the wind spin a propeller.

Few people know how a propeller works, and that's a surprise to me! Using simple materials such as straws and potatoes (or radishes!) and drinking straws or skewers, we can find where the draft is coming from and make it turn something we've made. Learning about how the wind works on things can help you design your own whirligigs.

Don't be afraid to do some simple stuff, kids' stuff. When we actually get down to it, there isn't much in the world that we haven't been doing since we were kids. I suppose we just take it more seriously—or ourselves.

I have a photograph of me taken when I was eight and a half. I look full of hope and trust. I have the picture right by my desk, and when I'm wondering what it's all about and worrying, I look at him and say, "That's me. Look after him."

The Air Is All Around Us

In the winter or when there is smoke in the air, we can see the air moving. We often think that we see the snow moving along by itself, but it's the air moving it in curls and spirals, fast and slow, heaping here, scouring the ice there. The air moves sand, rain, and mist. When there is something like smoke or snow or garbage blowing in the air, we see the shape of the air.

The air doesn't move only when it snows or rains; the air moves all the time. Maybe we can't see it moving, but it's there. When we feel a breeze on our cheek, that's the air moving.

The air is all around us; it's massive. The wind is moving air. When the air moves, it feels as though just bits of it are moving because we feel it on separate parts of ourselves and see separate things moving.

Moving air is like water. It flows around things and sometimes moves whatever gets in its path. The surface of a river or creek can show us these patterns. When a leaf or twig or some other floating object is in the water, it is easy to see the movement.

Under water, the force of the stream pushes around rocks and sand, showing where it has been. Plants flow in the water just as the snow patterns blow on a wintry road.

If the water or air hits an object straight on, it bounces back in the direction from which it came. When the air or water meets a sloping surface, it slides off, and if the sloping object is not firmly secured the water or air will move it.

You can feel this force if you put your hand out the car window when the car is moving. You can surf your hand on the current of air, but if you hold your hand upright, it will just be pushed back. (Be very careful if you try this.)

Playing With the Wind

We don't need a lot of materials to start having fun with the wind.

Get a drinking straw, a pin, a bead, and a little piece of thin paper (writing paper is perfect for this).

A Simple Weather Vane

Cut a slot in one end of the straw.

Push the little piece of paper into the slot.

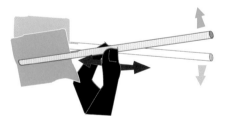

Balance the straw and the paper on your finger or fingers. When the straw is parallel with the floor, mark or remember the spot.

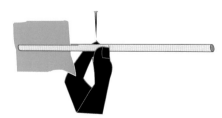

Push the pin through the straw, and wiggle it around to make the hole bigger but not so big that the head of the pin comes through.

The pin and the paper should be as close to parallel as you can make them without making it into a big deal!

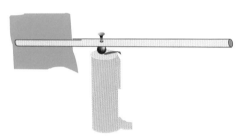

Stick the pin and straw and paper into the top of a crayon, candle, or cork in a bottle, or something else that you think will work. Note how the bead goes on the pin to act as a bearing.

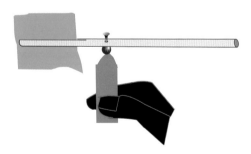

You now have a weather vane.

HELP

If the straw doesn't balance after the pin is in place, move the pin's position a little toward the low end of the straw.

Which Way Does the Wind Blow?

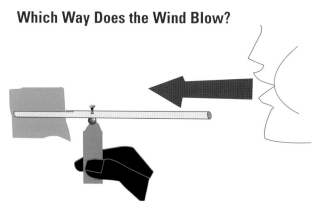

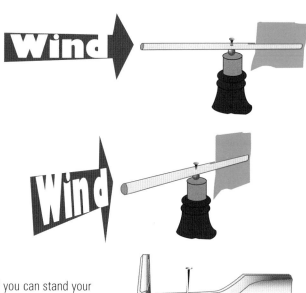

Hold up your weather vane in front of your face. It doesn't matter which way it is pointing.

Blow gently.

You will notice that the straw will turn until the paper is at the far end.

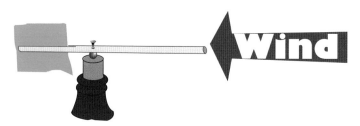

Carefully turn your weather vane so that the paper end is toward you. Blow gently. The vane will turn slowly away, until once more it is pointing straight at you.

When the wind blows, the big weather vanes that are on top of churches and barns turn just like the one that you have made.

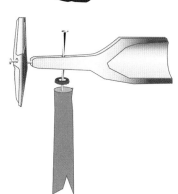

If you can stand your weather vane on a table or chair, move around it, and gently blow. You will find that it will always point to the place from where the wind is coming.

HELP

Do you find that when you push the straw onto the skewer it goes too far and makes too big of a hole?

As you push the straw onto the skewer, it will help if you pinch the skewer between the fingers of your other hand at the place where you want the straw to stop, about halfway down the pointy end.

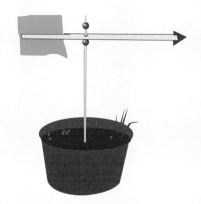

Weather Vane Variation

Make a weather vane like the one you've just created, but make a short cut at the other end of the straw too. Cut a little triangle from some colored paper, and put it in the short slot.

Balance the straw and put in a bamboo meat skewer. Push the straw about halfway down the tapered end, and then pull it off again. Put the straw gently on the skewer again—it should rotate freely.

Stick a bead or small piece of clay on the end of the skewer.

Stick the whole assembly in a pot of earth or sand. Place it in a handy spot where you can see it pointing into the wind.

Scissors

One of the most commonly used tools is a pair of scissors. A good heavy pair will cut thin metal and cardboard. A fine pair of scissors cuts nice delicate shapes.

Most scissors are made for right-handed people, so those who prefer to use their left hand can have difficulty using them. If you are left-handed, try to get a pair of left-handed scissors. They are hard to find, but are available at some stores. Ask the storekeeper about them.

The drawing shows both left- and right-handed scissors. It is difficult to tell the difference, but generally the left-handed ones are marked LEFT or L.

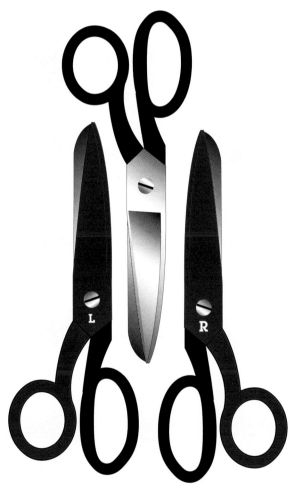

No, these are not just flipped—they are constructed differently!

Rotation

When you put something in the way of the wind, the wind tries to push it away. We saw that when we made a weather vane. If, though, instead of a plain front end, we have another vane, then it will push that one away and we have—rotation. We can call these turning vanes *propellers*. We should call them *rotors*, but nobody does and nor shall we—well, maybe just occasionally.

When the wind hits an object with a sloping surface, such as our vane, it bounces off (green arrow). The force of the bouncing makes the vane move in the opposite direction. Because the vane is tethered to the center, it will go around. Of course, we must remember that the wind is not just a gust—the wind keeps on forcing itself upon the vane, making it move away and rotate.

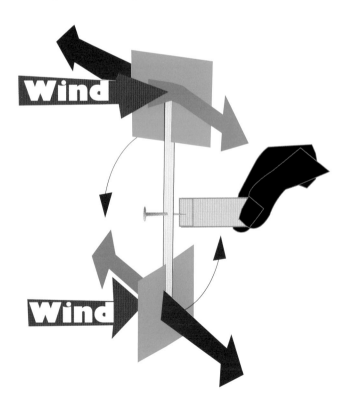

Rotating Weather Vane

To make a rotating vane, we have to make a slope for the wind to slide off.

Take a straw and make a slit in one end as before. At the other end, tilt the straw and make another cut. Put a piece of stiff paper in the slot at each end. The paper should be the same weight, shape, and size. Find the balance point. Insert a pin, as shown in the diagram, between the angle of the sloping papers.

 Push the whole assembly into a cork, crayon, or stick. The wind will make it revolve.

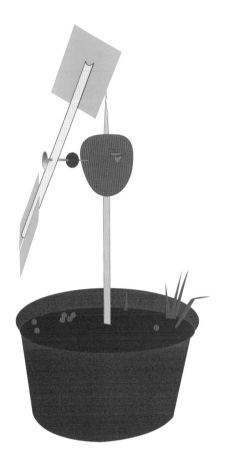

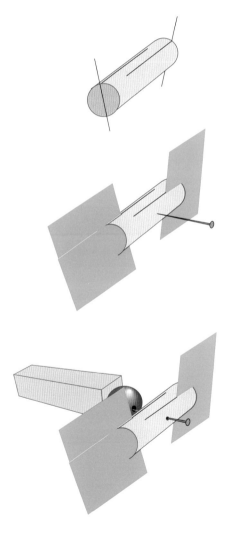

Try this. The brownish blob is a small potato or radish.

HELP

Balance is very important with this project. Here's what to do.

Get the straw to balance as evenly as you can. After you put the pin into a cork or crayon, adjust the balance by moving the paper in the slot. On the side that hangs low, move the paper toward the pin a little, or on the high side, move the paper away from the pin a little until just right.

3 Mobiles

Making things that move is fun!

Once there was a man named Alexander Calder who made moving toys, whirligigs, and whole circuses of moving acts and animals, such as lions, tigers, and bears. He gave shows for his friends and they had a lot of fun. Sandy (that's what his friends called him) loved the movement and after a while it didn't matter whether it was a trapeze artist or a dancing clown—it was the movement that he loved. So he made pieces that were fun just because they moved. He called them mobiles.

The simplest mobiles are very easy to build. The way they are put together makes them catch the air and move.

Working With Things That Change

When we make things that move, we are making things that change, and they get attention. Movement and change are sometimes the only things that we notice. A lot of people, though, just refuse to believe this. But imagine yourself sitting in a large room, waiting. Maybe you are at City Hall. As you sit gazing at the patterned wallpaper at the far end of the room, you see a fly. But the fly is so far away that there is really no way that you can see it. What you see is the movement of the fly. When the fly stops moving, you will lose sight of it.

I learned to make mobiles from a book back in 1952. I had a good time and made quite a few. The principles that Sandy Calder developed still work today, but not many people know how to make a mobile that actually moves.

We can make mobiles with very simple materials—coat hangers, skewers, dowels, or even cut-up cardboard boxes from the grocery store.

Cutting Cardboard

These knives look sharp, and they are! Don't make sudden movements when using them.

Corrugated cardboard is easy to cut if you do it in a relaxed way. The beauty of corrugated cardboard is that it is made of thin layers of light material that by themselves are quite flimsy.

Mark where you need to cut. Lay the cardboard on a cutting surface. Cut through the top layer and the corrugated (wavy, wrinkled) layer in the middle. Sometimes you'll need to press a little harder to cut through the bottom layer. If cutting a straight line, bend the cardboard a little, checking that you have indeed cut through the middle layer, and turn the cardboard over. You will see on the back the cuts that have gone through. Follow these marks to finish the cut. When cutting curves, do the same thing, except for the bending.

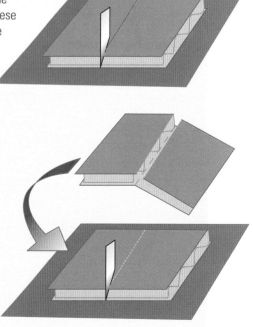

Constant Motion

Mobile means movable, and mobiles move. The air moves them. The air pushed our weather vanes and turned our propellers in chapters 1 and 2. We are going to use the same principles we followed when making them to make our mobiles move and turn.

As mobiles turn, they sweep across space. Each vane turns on its own pivot and pushes the other vanes into other positions. Because of this, the breeze acts on all the pieces differently, all the time. Therefore, we get constant motion. Cool!

On these pages are illustrations of a very simple mobile showing its different parts.

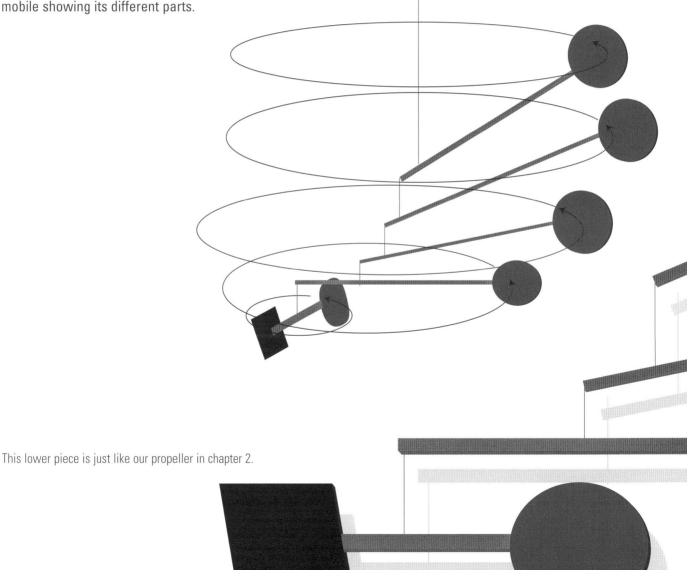

This lower piece is just like our propeller in chapter 2.

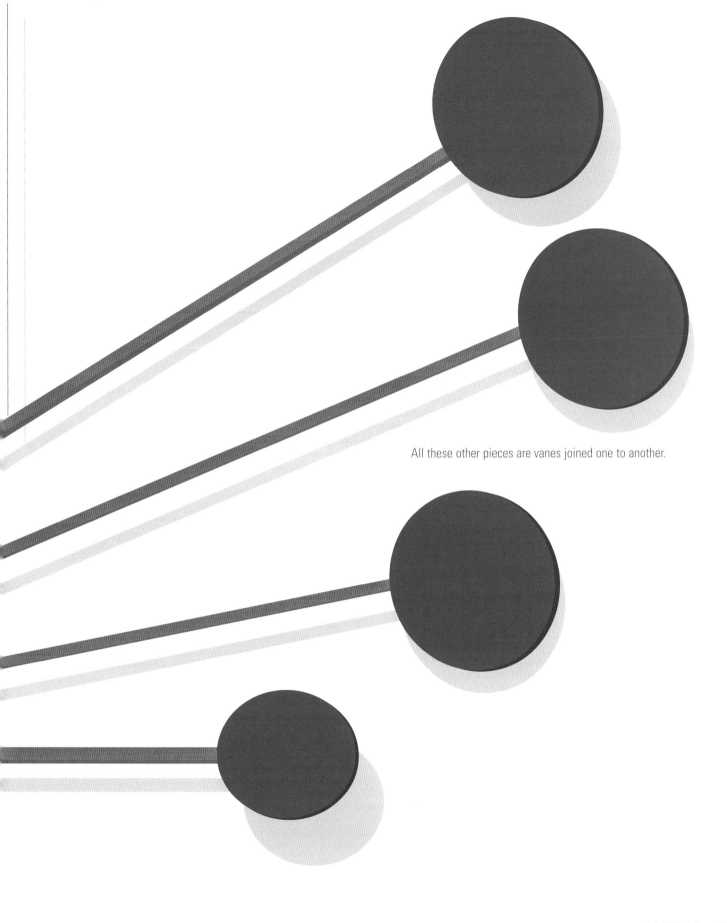

All these other pieces are vanes joined one to another.

How to Make a Mobile That Works

Get a box from the grocery store or somewhere like that. Take a stick. A bamboo skewer is good—you can get about fifty for a dollar.

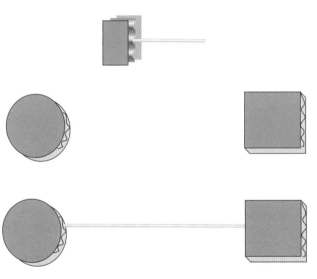

Cut out two pieces of corrugated cardboard from the box. The cardboard has spaces running through it. Stick one end of the skewer in one piece and, at the other end, do the same thing with the other piece of cardboard.

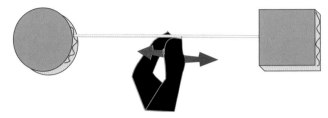

Find the balance point. You can get a rough idea of where the balance point is by resting it on your finger and thumb. Tie a piece of thread or thin string around the skewer. Hold the thread up, and let the two pieces and the skewer dangle. Slide the thread up until you find the level balance point.

This is nice, but if we just leave it this way, we will not have a mobile, because after it reaches the point at which the air has moved it, only dangling occurs. Just hanging things up doesn't make them mobiles. Mobiles have to move!

Lay the piece you have made on a flat surface. Put the thread up and away. Cut out another piece of cardboard. Put a skewer into a space in the cardboard as if making a weather vane.

Put the vane in position flat on the table, as in the illustration. Notice the two red arrows and the shaded area—make sure that your vane doesn't encroach upon this area. If it does, your mobile will bump into itself and become immobile (not what we want!).

Attach the first piece to the vane. Tie the thread and then put on a dab of glue. When the glue sets, cut off the ends for a neat appearance. On the vane stick, slide the thread to the level balance point and then finish up cleanly.

Adding More Vanes

If one vane is good, two are even better. How about three or four? It's up to you. Lay out your mobile on a bench as it will hang when in action. Make another vane and repeat the procedure that you used for attaching the first vane.

Make sure that the new vane does not interfere with the first one. There should be clearance between them. You can easily check this out on the bench by laying it down flat just as we did before.

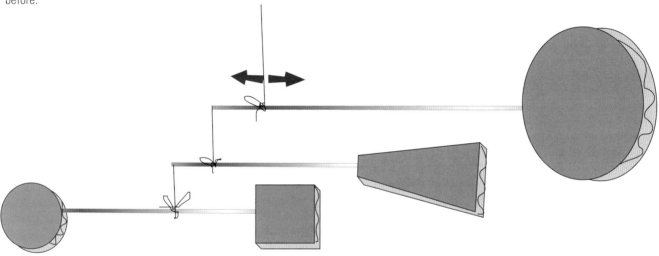

With the second vane in place, you will see a lot more movement. Add a third and a fourth if you wish. You may need to use a heavier stick, as the longer arms will tend to bend with the weight of the vanes.

What happens is this: The vane pushes the mobile into the stream of air and always presents it to the wind or breeze. The slight variations of swirling air catch the different parts and keep the mobile in motion.

HELP

If you ever need to adjust your mobile, always make changes from the lower end (the parts that you made first) and then work your way up the chain of vanes. If you try to work changes from the top end, you may get quite entangled.

Designing Your Own Mobile

We have made only a very simple mobile. From now on, the sky's the limit. If you follow the basic principles on the last few pages, you will be able to make all kinds of variations.

I always like this variation.

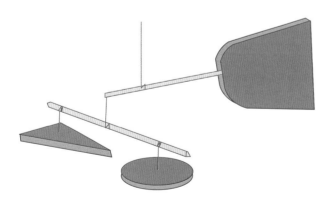

Pieces don't have to be vertical—they can be horizontal, as long as there is a vane to push them into the wind.

Get a book on Calder and see what he did.

Why not? Be daring!

Wire

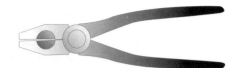

Flat-nose pliers

Wire is just a long thin piece of metal. The really thin stuff can be cut easily with scissors, and bending it with your hands is simple. For thicker wire, these special tools called pliers are useful.

Flat-nose pliers are common enough to be just called pliers. You probably have a pair around the house already. Flat-nose pliers have a slot in the side for cutting wire. They also have a section between the jaws that cuts.

For cutting wire, side-cut pliers do a better job.

Bending wire into tight curves can be done in many ways, but a pair of long-nose pliers is a good tool to have for this.

There are many types of pliers. Check out catalogs. Before you buy any, make sure of what you want the pliers to do. Don't buy glitzy pliers—you rarely will never need anything with super-shock, ergonomic rubber handles!

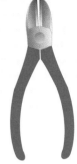

Side-cut pliers

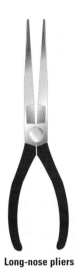

Long-nose pliers

There are many kinds of wire.

- Music wire is tough and very springy. It's difficult to bend, and it's hard to cut—you have to file it.
- Galvanized wire bends fairly easily. It's the most common wire around.
- Stove wire, sometimes called tempered wire, is very bendable and black.
- Copper wire is easy to work and looks nice.
- Clothes hangers make great wire. They are always available, but sometimes hard to cut.

Music wire

Galvanized wire

Stove wire

Copper wire

Clothes hangers

Adjusting the Balance

The vanes become harder to balance the further we get from the rotor. To get balance, you can increase the weight of the vane or move the pivot point. Increase the weight of the vane by adding more material. There are many ways to add material for balance. Here are just three of them. Keep adding until you get the balance.

Glue on some pieces.

Slot on some pieces.

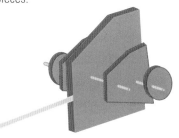

Skewer on some pieces.

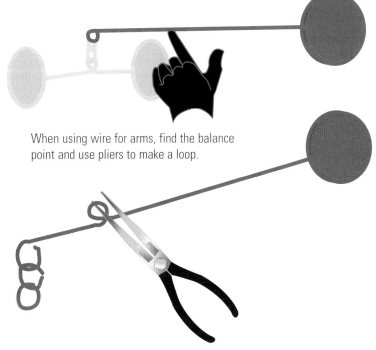

When using wire for arms, find the balance point and use pliers to make a loop.

Wire chains join the parts. Make a loop on the end of a long piece and cut it off. Do this several times and join the links.

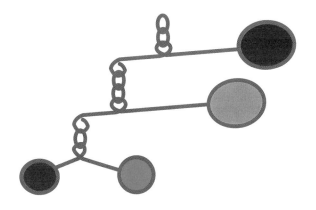

You can make this vane larger (heavier) to get balance.

Dowel can be used when you need longer arms. It comes in lengths of up to 4 feet.

HELP

To finish the cardboard, use glue and tissue paper as well as some paint (see page 36 in the chapter on stabiles).

Don't try balancing or rebalancing when the paint or tissue is wet—wait until it dries.

4 Jumping Jacks

Jumping jacks can be any size, any shape, any color, any anything.

These toys were so popular in Paris in the eighteenth century that the police banned them. They thought that these crazy, innocent amusements would cause children to be born with defective limbs! Nowadays the police are busy with other things, so, using cardboard, string, crayons, paints, whatever we need, we can make as many as we want—legally.

As we saw in the last chapter, mobiles can move by themselves, with a little help from air currents. Jumping jacks move when you pull the string. When we were balancing the vanes on the mobiles, we were actually working with levers—something we'll be getting to know much more about. Jumping jacks have arms and legs that are second-class levers, but jumping jacks don't take themselves very seriously and they are always first-class company.

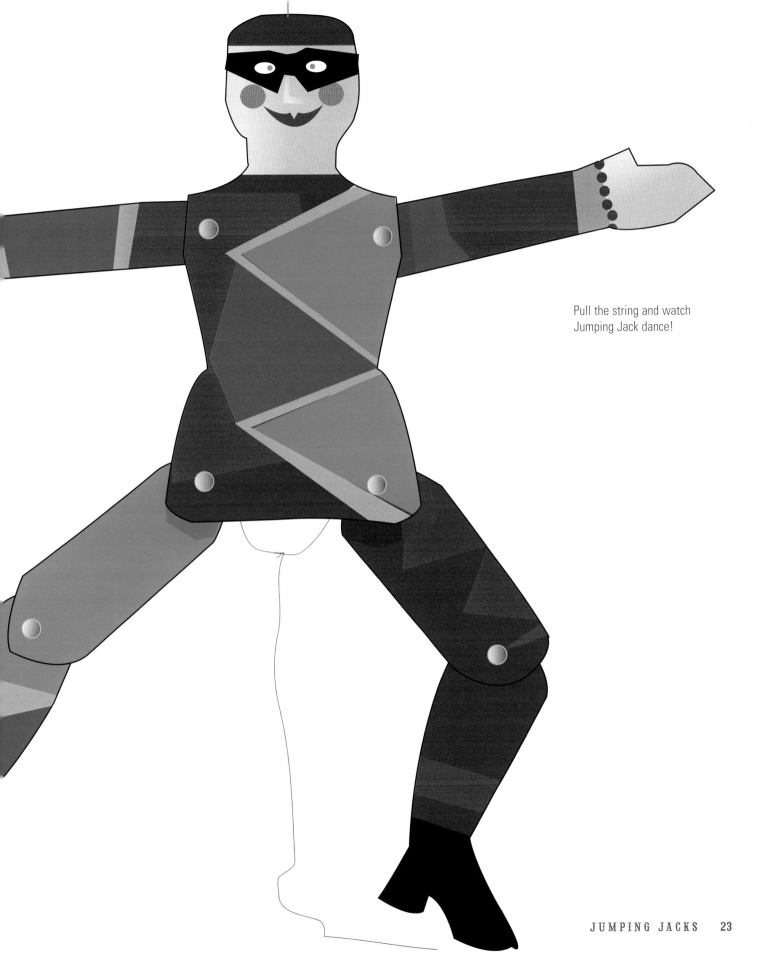

Pull the string and watch
Jumping Jack dance!

Making a Jumping Jack

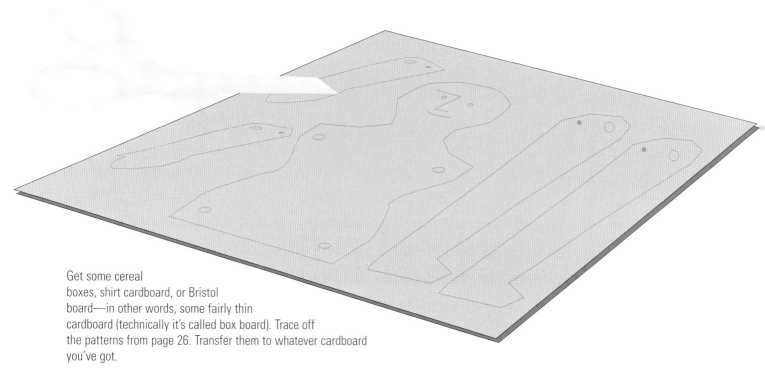

Get some cereal boxes, shirt cardboard, or Bristol board—in other words, some fairly thin cardboard (technically it's called box board). Trace off the patterns from page 26. Transfer them to whatever cardboard you've got.

Jumping jacks can be made of just about any stiff material. Wood works really well, and you get a lasting, substantial toy. You'll have to figure out a way to make the pivots and other such details, but go ahead anyway and design your own.

Paper fasteners

The arm and leg joints can be knotted string, twisted wire, or anything that you have at hand. If you are near a stationery store (I think they call them office supply stores now), get some paper fasteners.

The two thin prongs at the back are pushed through the hole and then bent over. The prongs come in different lengths—for this project, ¾ inch is good. A couple of bucks gets you a box of 100.

HELP

If the legs and arms don't swing easily, what should I do?

The pivots in the body don't have to be loose, but in the arms and legs they do. Check that the paper fastener is not binding. If you have one, use a hole punch for the arm and leg holes. If you don't have a hole punch, cut a hole with a knife; it doesn't have to be a round hole.

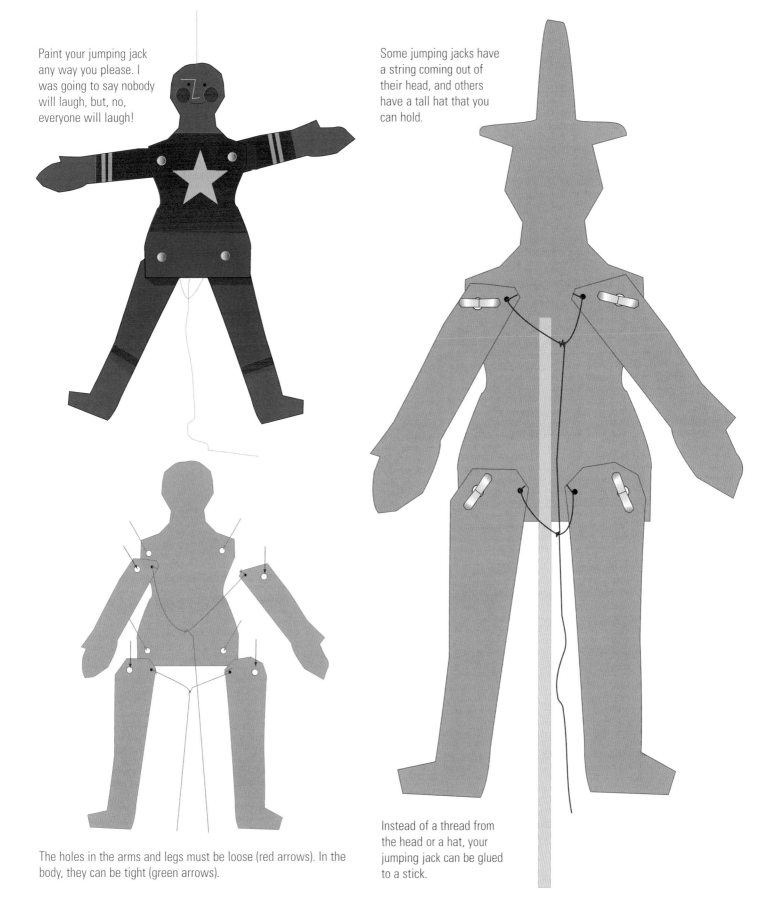

Paint your jumping jack any way you please. I was going to say nobody will laugh, but, no, everyone will laugh!

Some jumping jacks have a string coming out of their head, and others have a tall hat that you can hold.

The holes in the arms and legs must be loose (red arrows). In the body, they can be tight (green arrows).

Instead of a thread from the head or a hat, your jumping jack can be glued to a stick.

Jumping-Jack Shapes

The shapes of jumping jacks are just as varied as the shapes of all those people you see on the street—fat, thin, tall, with long arms, with big feet, and so forth. Once you've got the idea of how a jumping jack works, you can design and make your own—or make two or three or 20 million—that's OK.

Just to get you started, here are the shapes for my jumping jack. You can choose to make either one-piece or two-piece legs. You decide.

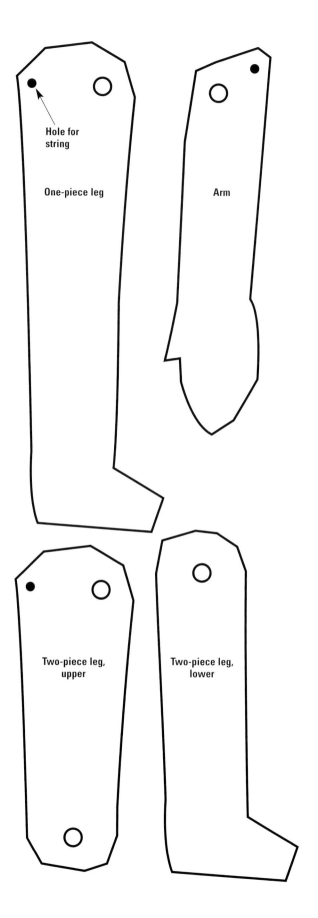

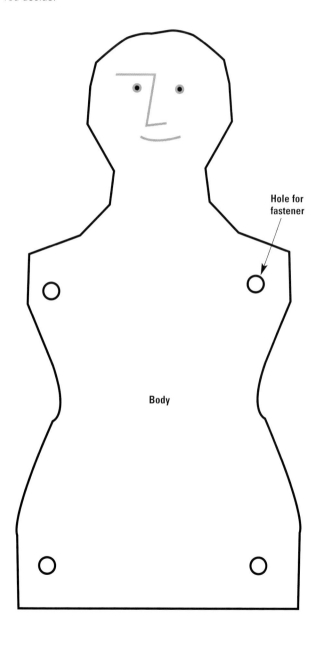

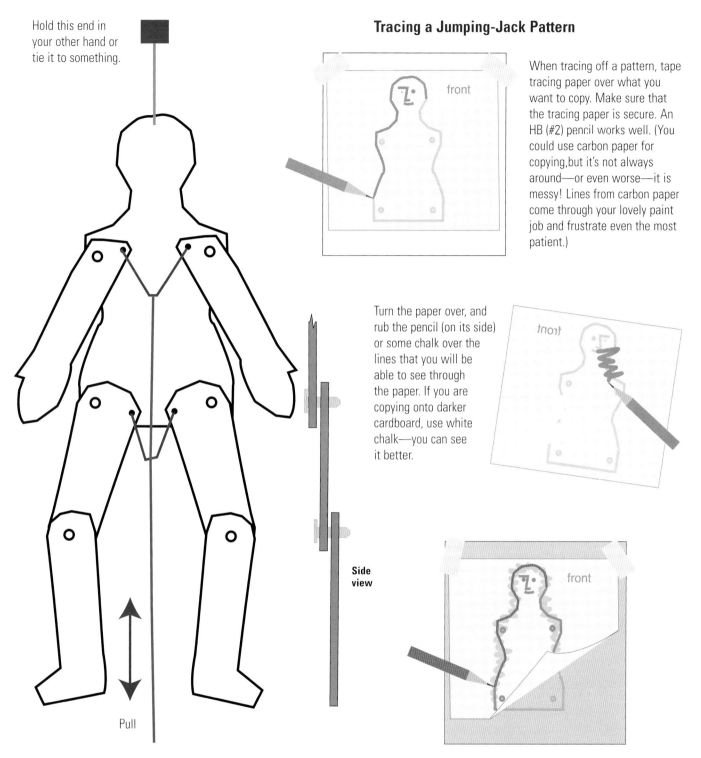

Hold this end in your other hand or tie it to something.

Tracing a Jumping-Jack Pattern

When tracing off a pattern, tape tracing paper over what you want to copy. Make sure that the tracing paper is secure. An HB (#2) pencil works well. (You could use carbon paper for copying, but it's not always around—or even worse—it is messy! Lines from carbon paper come through your lovely paint job and frustrate even the most patient.)

Turn the paper over, and rub the pencil (on its side) or some chalk over the lines that you will be able to see through the paper. If you are copying onto darker cardboard, use white chalk—you can see it better.

Side view

Pull

Tape the tracing face-side out to the surface to which you wish to copy. Draw firmly over your original lines. Remove the tracing paper.

I use a colored pencil for this last stage. Colored pencils are smooth and you can see where you've been.

Putting on the string can be tricky, because it is put on before the arms and legs are attached. Guess how much you need, and don't tie it tight. Put the pieces together with fasteners; then adjust the string and firm it up.

Notice in the side view that the two-piece legs are layered to avoid tangling.

5 Talking Heads

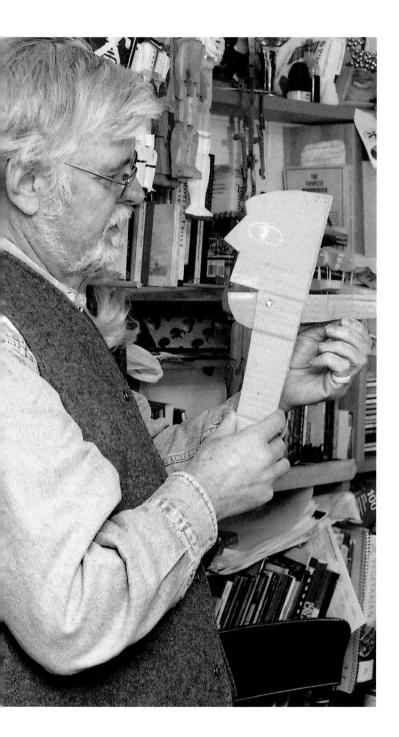

W ell, they don't really talk—you do that. Another option is singing or making rude sounds, but be careful who's around—not everyone has a sense of humor!

Talking heads are a simple form of puppet. They are useful for plays and for telling things, to yourself and to others.

Rodney:	Hello. I didn't expect to see you here so early.
Talking Head:	I'm practicing getting out of bed. (Looking around) This room could do with a bit of tidying.
Rodney:	Yes, but I have to do the laundry today, so the room can wait. And then I have to make a sign for Gord and then . . .
Talking Head:	Boy, you sure have a busy life!

Making the Jaw Move

Remember cardboard, the gold mine of making stuff? Get some and we're ready to go.

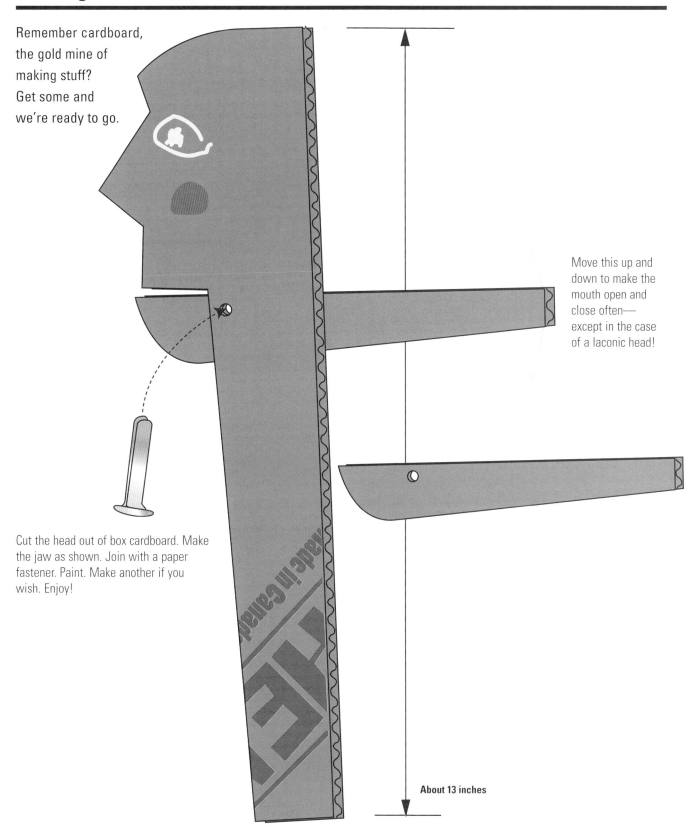

Move this up and down to make the mouth open and close often— except in the case of a laconic head!

Cut the head out of box cardboard. Make the jaw as shown. Join with a paper fastener. Paint. Make another if you wish. Enjoy!

About 13 inches

Putting a Moving Eye into Your Talking Head

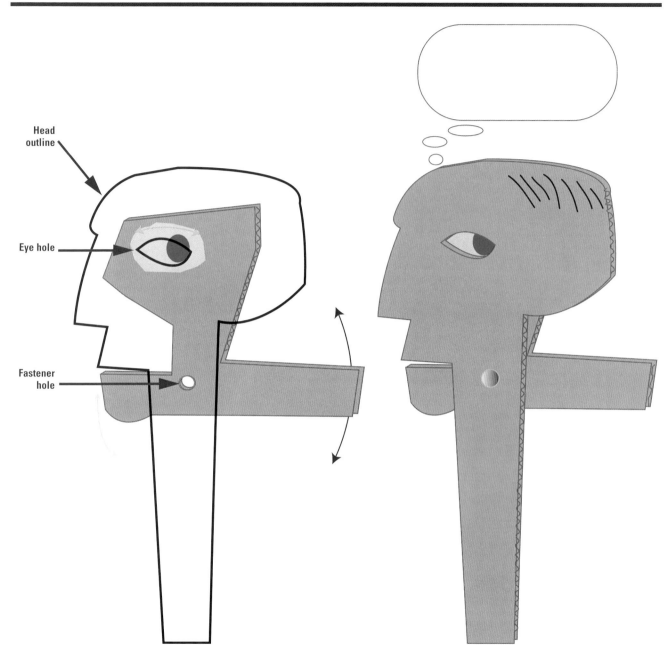

Head outline

Eye hole

Fastener hole

This is a slightly more interesting effect than moving the mouth. The black outline shows you the head shape and the eye hole. When you have cut out yours, put it on a fresh piece of cardboard and draw around the outside and in the eye hole. Now you can design your jaw and eye piece with a lever at the back for moving the jaw and eye.

It will take a bit of thinking to figure out how much to leave around the eye. Try what you think is right, and if something sticks out at the front or you get a space in the eye hole, try again.

Levers

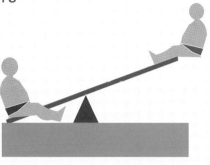

A teeter-totter, or seesaw, is a big lever. Did you ever notice how, if the other person is bigger than you are, you have to sit back a bit?

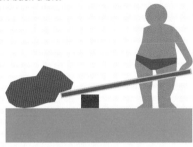

To lift a rock, we sometimes put down a brick or chunk of wood to pry it up. We are using a lever—levering it up. That's what it means to pry.

Try this. Get a stick to represent a lever. Hold it in two fingers. Move one end up and down. Notice how the short end doesn't travel very far while the long end moves farther.

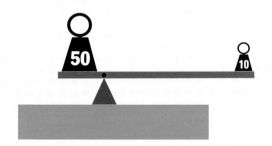

We can use this to our advantage, because even though we have to move the long end farther, we can apply less effort.

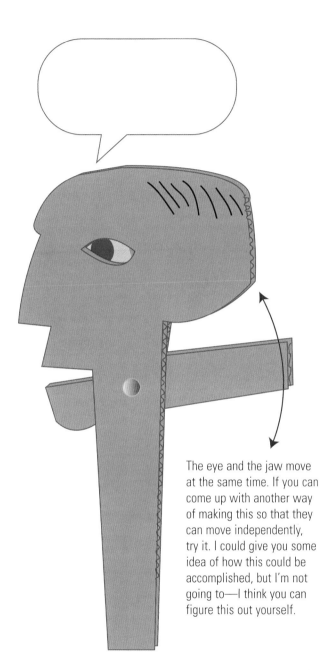

The eye and the jaw move at the same time. If you can come up with another way of making this so that they can move independently, try it. I could give you some idea of how this could be accomplished, but I'm not going to—I think you can figure this out yourself.

HELP

If a head is not talking, is it thinking?

Can we talk and think at the same time?

Why do we talk anyway?

Is thinking good for us?

We cannot *talk*, but can we not *think*?

6 Stabiles

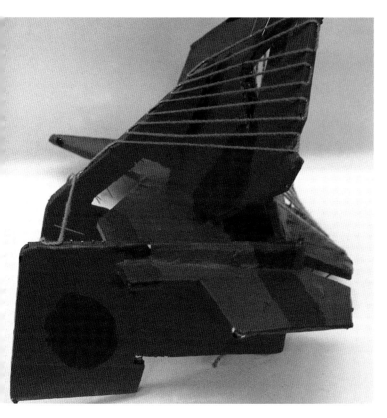

It's all about space.

What is a chapter on stabiles doing in a section about getting things moving? you may ask. Well, stabiles are about getting to know space and not worrying about if they mean anything or look like anything—they are something that just *is*. A stabile doesn't have a top or a bottom, and if this is the case, how can it have sides? Thinking and not thinking are what a stabile and this section are about. If a stabile is about thinking and not thinking, and up is down and there are no sides, then a stabile is not about anything except what it is.

Now that that's cleared up, let's get started.

HELP

What is a stabile and how do you say it?

A stabile is an abstract sculpture that doesn't move.

One day the artist Hans Jean Arp said to Sandy Calder, an artist known for his mobiles but who was then making some static pieces, "And these things I suppose are called stabiles."

As an erstwhile Englishman living in Canada, I would have a tendency to rhyme *stabile* with the way I say mobile— *moh-byl*, so *stay-byl*—but I don't like it much. However, I imagine Arp said it in French: "And these things, I suppose, are called sta-beeels"—which is kinda nice!

Change your size and imagine
yourself walking right into your work.
Look up and around. What do you
see? How do you feel?

Making a Stabile

Put in another piece, perhaps to support and reinforce the other two pieces.

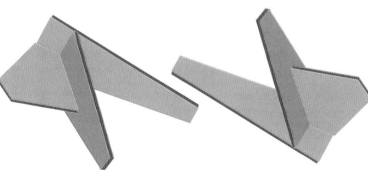

Dressmakers' pins are good for joining cardboard. Any glue works well.

Get some cardboard and cut it up into a whole bunch of pieces—some small, some large. Cut mostly straight lines; curves can be difficult. Later, you will have some good ideas, and you might like to try making curves. Until then, stay with the straight cuts.

Have all your pieces in a heap near you. I've shown lots. You don't need to have this many; half a dozen is good.

Remember that your stabile looks only like itself. It may suggest other things to you, many things to you—a bird, a panther, a boat, a bench. Pay no attention to them; work on your stabile, which is just itself.

Rotate your stabile.

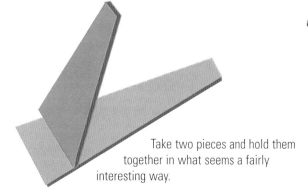

Take two pieces and hold them together in what seems a fairly interesting way.

All the while, remember that there is no top or bottom.

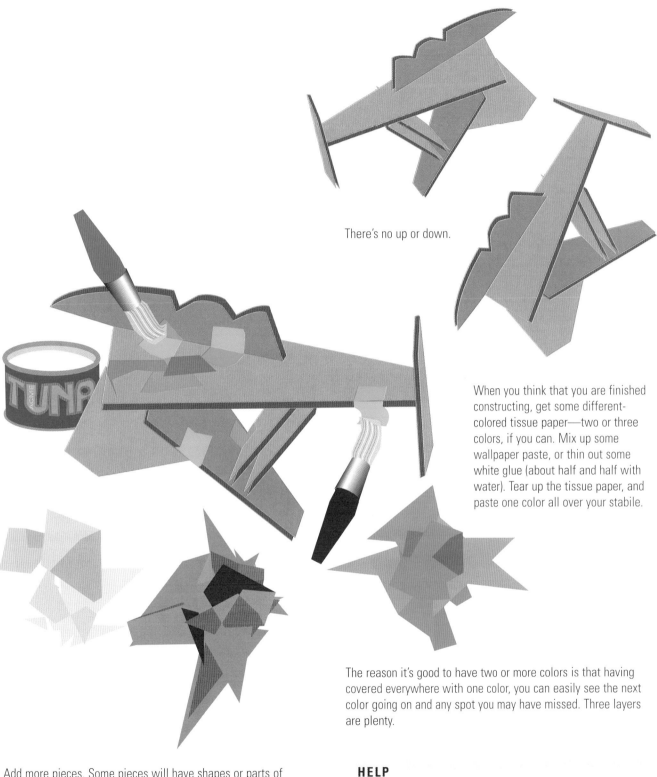

There's no up or down.

When you think that you are finished constructing, get some different-colored tissue paper—two or three colors, if you can. Mix up some wallpaper paste, or thin out some white glue (about half and half with water). Tear up the tissue paper, and paste one color all over your stabile.

The reason it's good to have two or more colors is that having covered everywhere with one color, you can easily see the next color going on and any spot you may have missed. Three layers are plenty.

Add more pieces. Some pieces will have shapes or parts of shapes that are the same as or similar to parts that are already there. This is good—we call this *repetition* or *rhythm*. Try putting a piece the other way, which will create *contrast*.

HELP

To get a really neat-looking stabile, make sure that you paste the tissue paper down carefully, pushing it into corners (see green brush) and wrapping it around the edges (red brush).

Painting Your Stabile

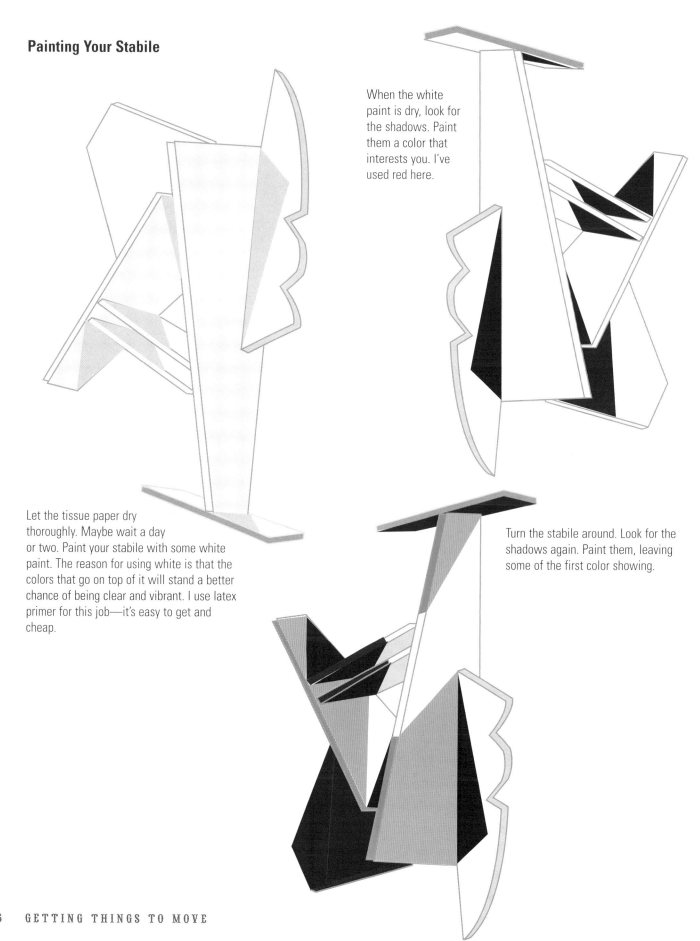

When the white paint is dry, look for the shadows. Paint them a color that interests you. I've used red here.

Let the tissue paper dry thoroughly. Maybe wait a day or two. Paint your stabile with some white paint. The reason for using white is that the colors that go on top of it will stand a better chance of being clear and vibrant. I use latex primer for this job—it's easy to get and cheap.

Turn the stabile around. Look for the shadows again. Paint them, leaving some of the first color showing.

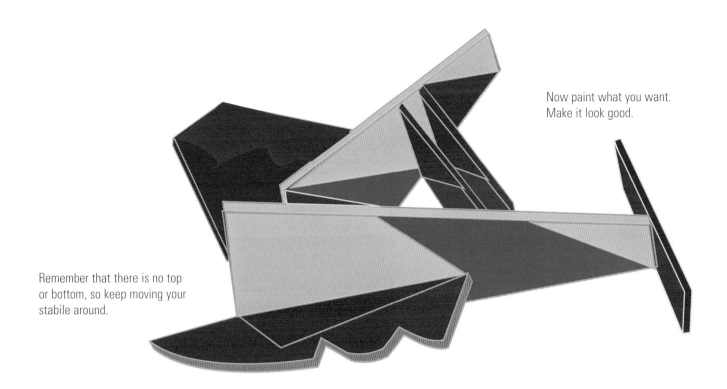

Now paint what you want.
Make it look good.

Remember that there is no top
or bottom, so keep moving your
stabile around.

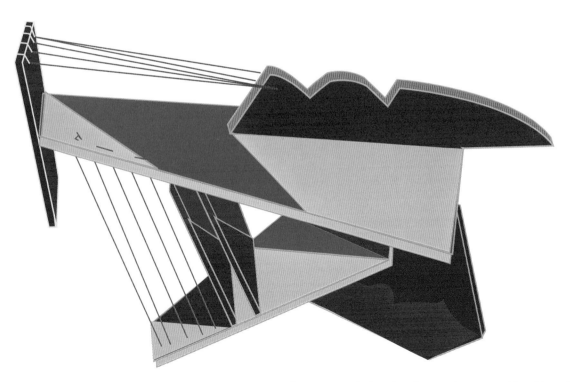

Get some wool, thread, string, or wire—something thin and
long—and put in some invisible/visible walls. These are like
looking at a glass—you can look at it, or you can look through it.
Can we do both at the same time? I don't know!

7 Puppets

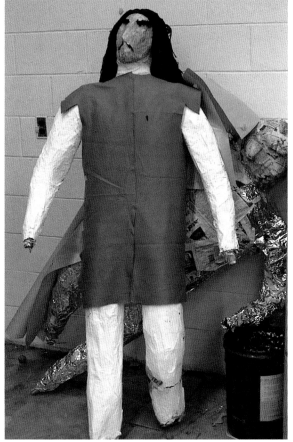

Puppet figures can be small or big—
or even bigger!

Puppets are a form of kinetic art, though they usually aren't thought of as such. We think of kinetic art as standing alone, but we are often required to turn, push, or operate the pieces in some way—to become involved. Puppets are also like that.

There are many different kinds of puppets—glove puppets, marionettes, shadow puppets, pop-up puppets, and a few more. Thinking of them as kinetic art puts them in a different light. Puppets can express feelings that we have and are perhaps afraid to talk about to others. With kinetic art, we can express fears, and because movement causes laughter, we can make fun of those fears.

I've always had a fear of drowning, so I created a show about the sinking of the Titanic. It was run by a tiny wind-up motor that went for a minute and 16 seconds. I try to hold my breath until the motor runs down, but I haven't managed that yet! There's a picture of it on page 82.

Get Inside Your Art

Get involved with your art, with the materials and the tools that you use. Talk to them. Get right inside the piece. You are the art. The materials are the medium.

Medium means the middle, the in-between, as with the medium at a séance. The medium is not important—nurture it, enjoy it, help it, listen to what it says, but most important, listen to what you, with its help, are saying.

I will be repeating this sometime. Watch for it. It's important. It's important sometimes to repeat things. Musicians play the same tune over and over until they get it right, 'til they know it. When doing visual art, some say that they've done that before so they're not doing it again well, but remember you can never step in the same river twice!

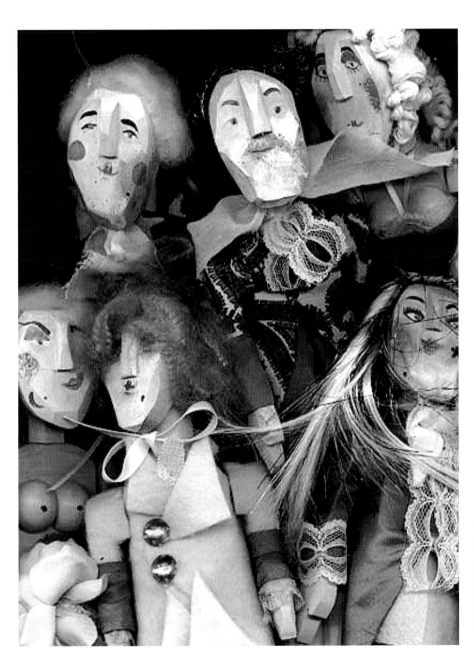

Make your dolls or puppets any shape you want. Have them come from any place in time. Let them have their own lives. Let them tell you things (you don't have to believe everything they say). Be Alice in Wonderland. You will discover a whole new world.

8 Moving Ball

Take an object, such as a ball, and move it with your hand from side to side. You are moving the object in space.

Kinetic art is about movement. Instead of putting colors and shapes on a surface, you work with movement.

You might want to imitate a movement that already exists, such as that of a person walking, or you may want to create something just for its own sake—for the enjoyment of seeing it go. Whatever you want to do, it's good to know a little about certain mechanisms and how to stay concentrated on what you want to achieve, rather than merely being seduced by the miracle of making something. Say to yourself, "What is the action I wish to achieve?"

Making Something Move

We are going to start with something very simple. We are going to make a ball move.

When we are at the theater, we know that what we see are actors on a stage, but we suspend our disbelief and accept them as being whatever we are told they are. Likewise, with kinetic art, we know that the ball is not floating in space, yet we choose to ignore the wires and strings. We want to enjoy the emperor's new clothes.

Work From the Top Down

The important part of kinetic art is the movement, the action.

I always start at the top and work my way down. I decide on an action, and then I ask myself these questions: "How do I get this to move?" "What should I do to get it to go the way I want it to?" "What do I need to do so that can happen?" "How do I support this, and how can I connect the whole thing to exist in the world of gravity in which we live?"

I have often tried to make a piece from the bottom up. I have made a base and very sensibly tried to work my way upward to the action. I cannot do it! I find that when I start at the bottom, in a conscious manner, my left brain begins to dictate to me and the machinery takes charge of the idea. The machine is very important, but the idea is more important than the machine.

Ball and Stick Machine

Get a little ball about 1 inch in diameter. Look for a Styrofoam or wooden ball. If you can't find a ball, cut a disk out of corrugated cardboard or a cereal box. I painted mine red, but you can paint yours any color you want.

Now take a meat skewer, the kind that you can buy for making shish kebab. Stick the skewer in the ball—of course, if you have a wooden ball, you will need to drill a hole (usually ⅛ inch).

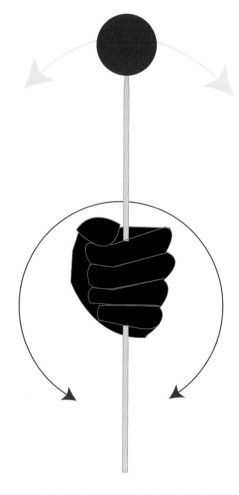

Hold your wrist still, and turn your hand as if turning a key in a lock. Watch the ball.

This is the action we will mechanize. Remember the action.

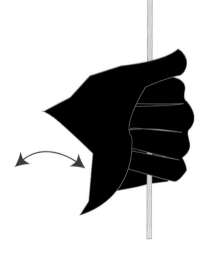

Hold it up, and waggle it from side to side.

Get a cardboard tube—toilet paper roll, wrapping paper center—something like that.

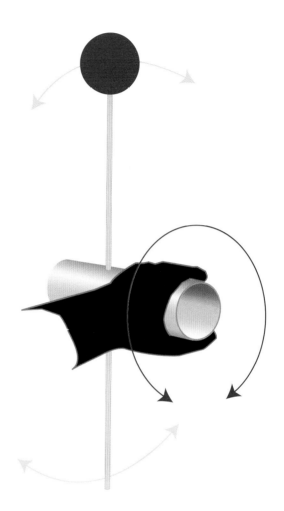

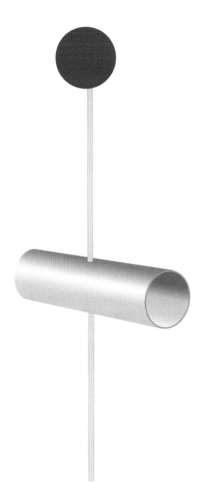

Push the skewer through it. You may have to drill a little hole. Cardboard is softer, so don't make the hole as big as the skewer; make it a bit smaller.

Hold the tube in your hand, and turn it to move the ball. **_Remember the action._** Notice how when the ball moves in one direction, the other end of the skewer moves in the opposite direction.

You now have a kinetic sculpture—a few more steps will convince you.

Preparing the Box

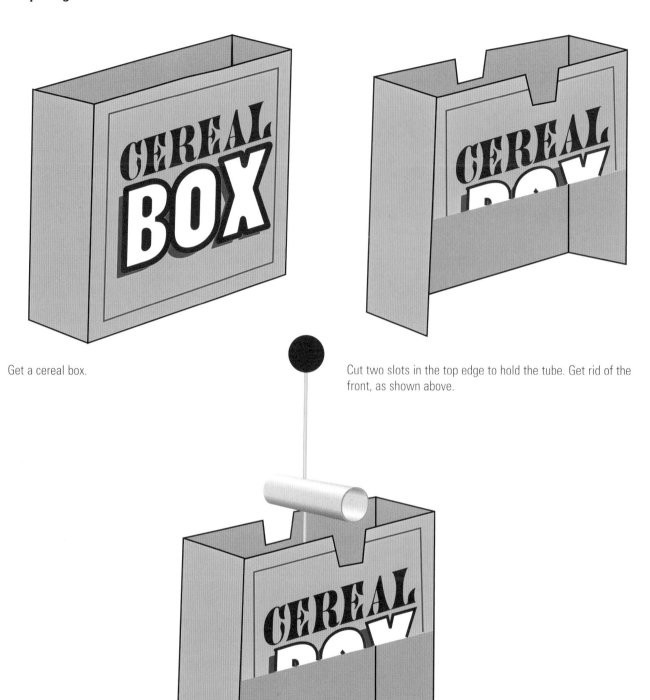

Get a cereal box.

Cut two slots in the top edge to hold the tube. Get rid of the front, as shown above.

Put the tube in the two slots.

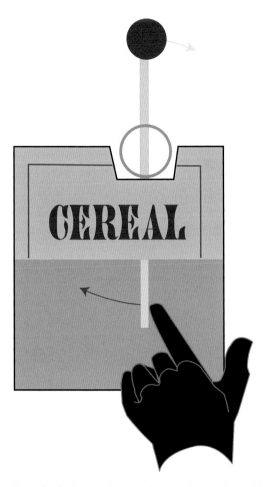

Put your finger in the box, and move the stick from side to side.

Remember your action? See your action!

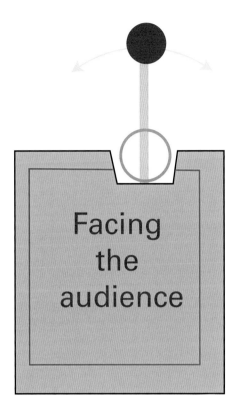

It's often hard to separate yourself from the knowledge of having created something. Others can see the magic of the movement. To see what they see, hold your box up to a mirror and make the movement. Looking at your work in a mirror is a good way to see what others see.

Adding the Control Stick

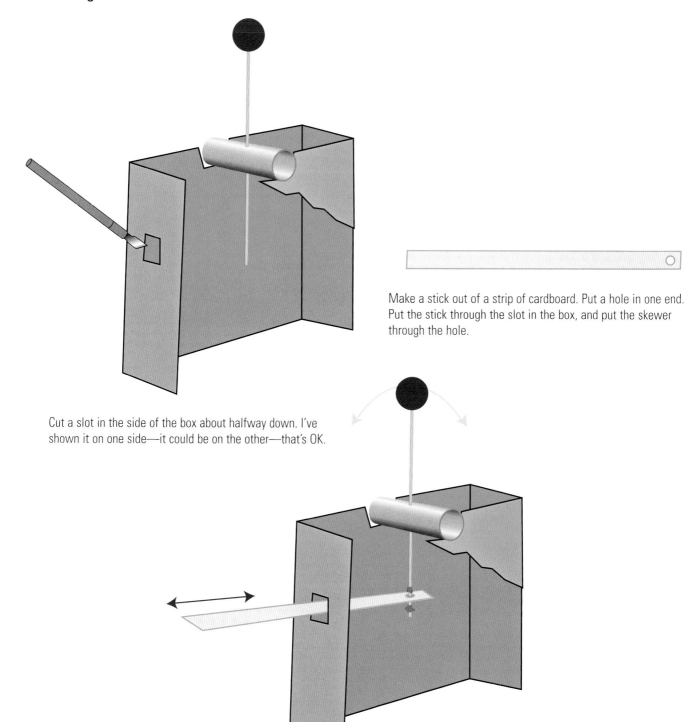

Make a stick out of a strip of cardboard. Put a hole in one end. Put the stick through the slot in the box, and put the skewer through the hole.

Cut a slot in the side of the box about halfway down. I've shown it on one side—it could be on the other—that's OK.

A little modeling clay (or any kind of clay) above and below will keep the skewer in position. This may be tricky to do, but be patient, keep at it—nobody's timing you.

Trying the Action

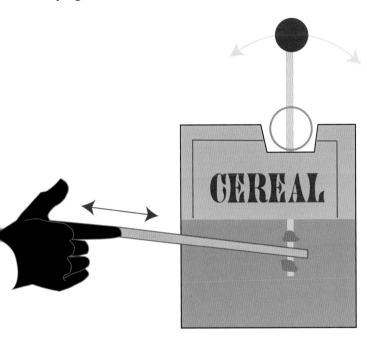

By removing ourselves from the action with this stick, we are able to appreciate the movement more and add to the mystery.

On pages 48 to 50 are some further possibilities.

Drilling Holes

Sooner or later, when doing kinetic art, you are going to have to make some holes in wood, metal, cardboard, or whatever you are using.

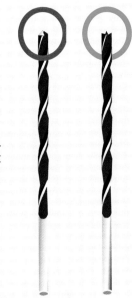

On the right are two types of drill bits. The one circled in red is for metal, though it works in wood too. Notice the conical end. Get a ⅛-inch and a 1/16-inch. Don't buy a big set!

The bit circled in green is a brad point. It works well in wood, boards, and cardboard—it cuts a clean hole. Get a 3/16-inch, ¼-inch, and 5/16-inch. A set of utility brad bits is good to have.

To hold the bits, use one of these.

The **electric drill**, which I understand is in 99 percent of all households, is familiar to everyone.

The **hand drill** is a very useful tool. Look for one at garage sales and flea markets. Don't pay big bucks just because they say it's an antique! A used one in good condition should be fairly cheap. A new one could cost you four times as much.

If you are going to get serious about kinetic art, invest in a drill press, because you can count on it to drill accurately. They cost about twice as much as the hand drill, but use the money you didn't spend on a new one!

Possibilities—Levers, Cranks, Eccentrics, and Cams

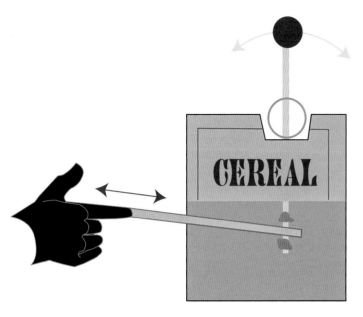

Pushing the stick is a good start, but we can do lots more to increase the mystery and amaze ourselves and others. For this next part, I have abandoned the cereal box, which was fine for a simple start but doesn't work very well if you want to add things to it.

Above is a simple construction of two boards joined together. The upright board is like the back of the cereal box, and the base is just that—a base, to which you can attach things. This drawing is a *perspective drawing*; all the others here are known as *elevations*.

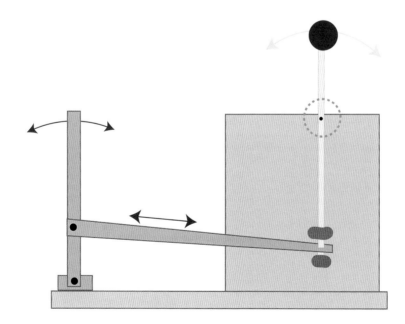

Here, we see a simple **lever**, pivoted in a block. When the lever is moved, the connecting rod moves the stick and ball.

Note: From now on, the pivots are shown as black dots •

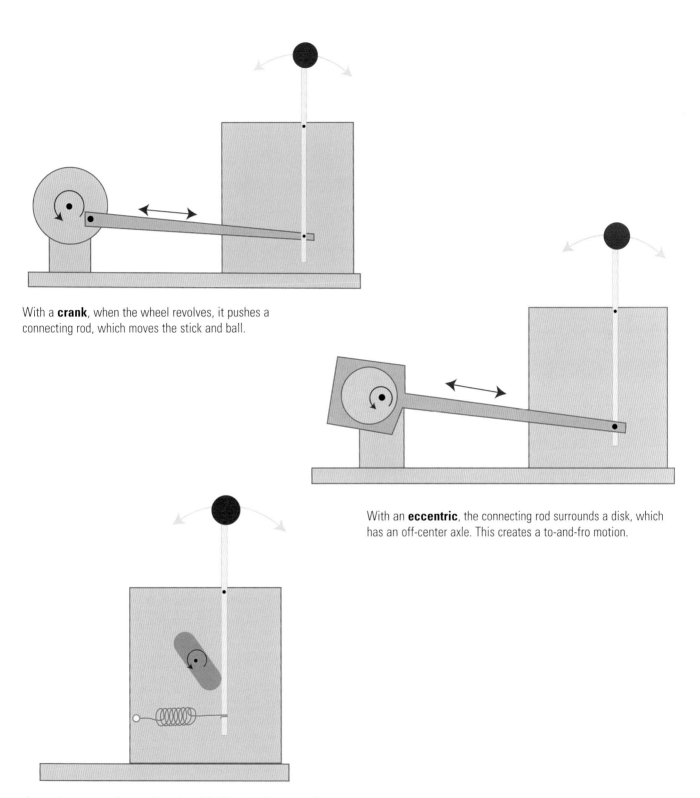

With a **crank**, when the wheel revolves, it pushes a connecting rod, which moves the stick and ball.

With an **eccentric**, the connecting rod surrounds a disk, which has an off-center axle. This creates a to-and-fro motion.

A rotating **cam** pushes against the stick. The stick is returned from its farthest travel point by a spring.

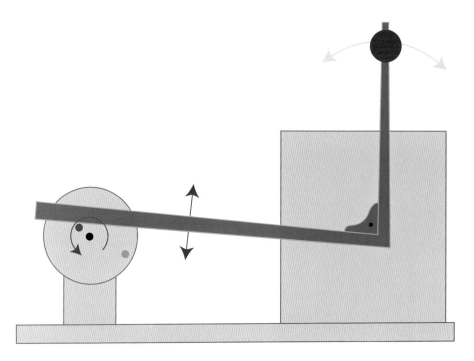

The connecting rod and stick have been made one. The rotating disk has two studs on it. The connecting rod rests upon the studs. The green stud pushes the rod higher than the red stud, providing alternating large and small movements.

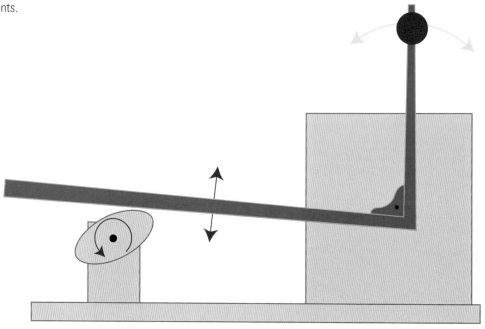

A cam is similar to the stud wheel. (To learn more about cams, see the next chapter.)

USING MECHANICS CREATIVELY

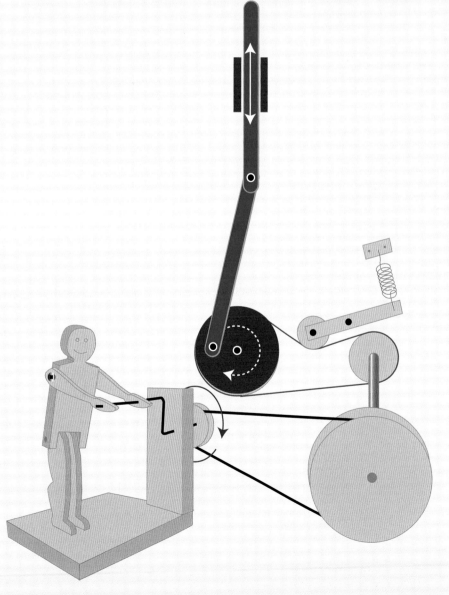

9 Cams

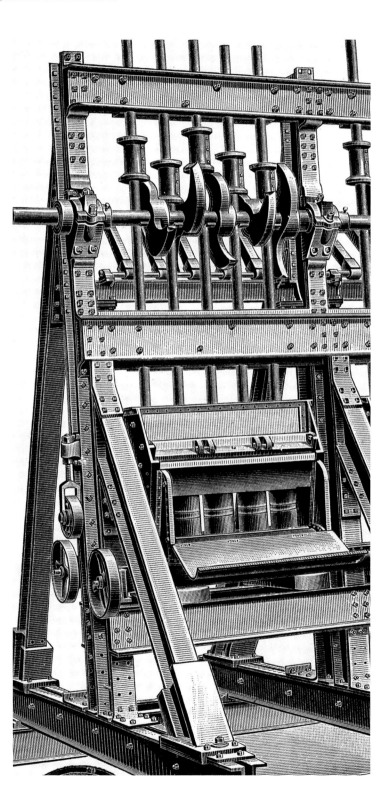

Denis delivers newspapers down our street. Every time his wagon goes over a bump, the wagon goes up and then the wagon comes down. It's the same for each wheel. This is what a cam does. It pushes things up and then they come down again. Imagine Denis going over a corrugated driveway. We can have cams that create the same effect.

Cams are very useful tools for the kinetic artist. Cams rotate on axles. Working in conjunction with levers, they can be made to push and pull, make intermittent movements, and repeat movements. With cams of the right shape, we can make sudden moves and slow moves. You design the cam to do what you want it to do.

Old engravings are a gold mine of information and ideas. Here are some cams on a machine. The cams are the spidery things beside the bits that look like thread spools. There are five cams on one axle.

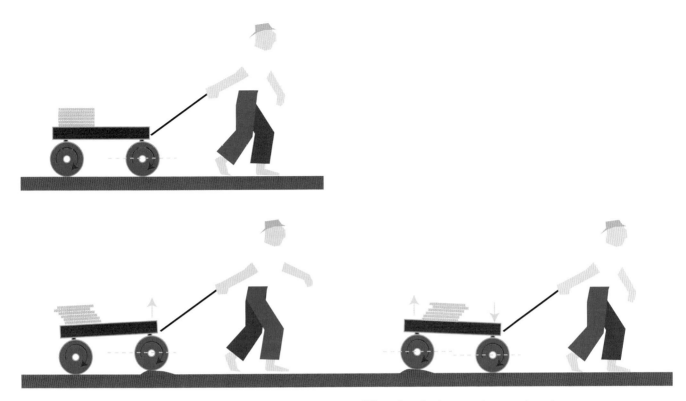

When the wheel goes over a bump, the wagon goes up.

When the wheel comes down, so does the wagon.

This is the ground and the bump. It acts the way a cam functions. It pushes something up and then lets it down again.

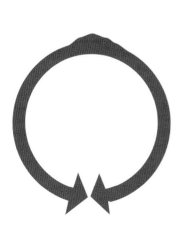

Cams rotate. If we take one end of the "street" and join it to the other, we have a cam.

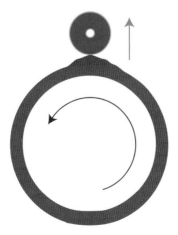

The cam rotates. When the bump is under the wheel, it pushes the wheel upward.

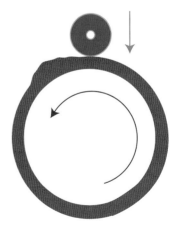

The cam rotates. The wheel goes down the other side of the bump.

What Can a Cam Do?

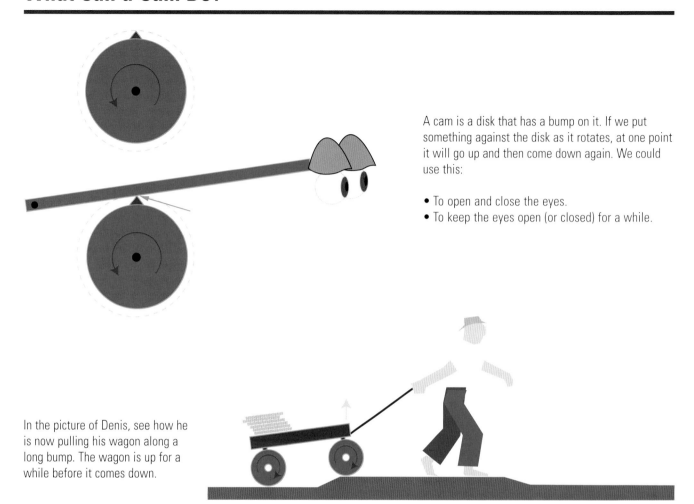

A cam is a disk that has a bump on it. If we put something against the disk as it rotates, at one point it will go up and then come down again. We could use this:

- To open and close the eyes.
- To keep the eyes open (or closed) for a while.

In the picture of Denis, see how he is now pulling his wagon along a long bump. The wagon is up for a while before it comes down.

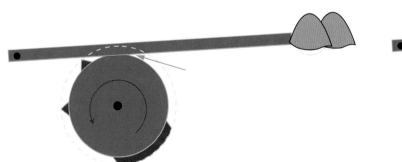

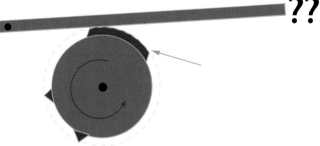

Here, the eyes are closed. The lever resting on the cam is in the down position (green arrow). The eyes will pause before opening.

When the cam gets around to the long red part of the cam, the eyes will stay open for a while. They will pause before closing. This pause is called dwell.

Cam With a Follower

For smooth operation, it is sometimes best to contact your cam by way of a *follower*. This can be a small wheel that runs on the cam.

These three cams show:

a—a sudden drop once every revolution, followed by a gradual rise

b, b—an equal drop twice in every revolution

c, d—two drops per revolution (one small and one large)

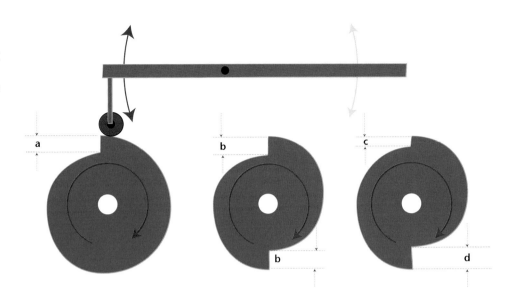

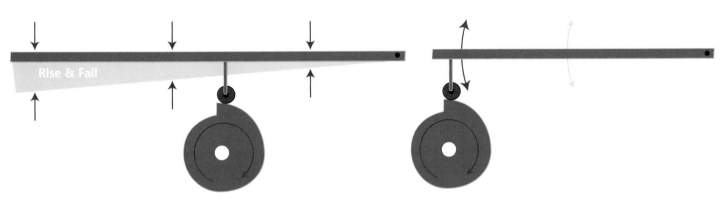

Different points on the lever provide different amounts of rise and fall with the same cam.

Linkage to the cam can be direct, as with the eyes opposite, or with a follower and lever, as above. Be flexible when building, and remember that there are levers of different classes.

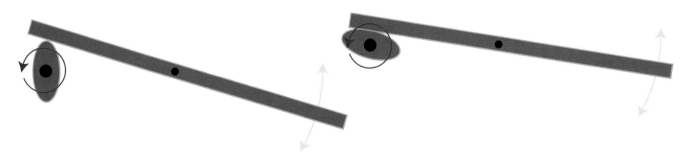

This simple oscillating cam has many uses and is easy to make. It's good too for determining what you need in a cam.

The simplest solution is usually the best.

Cam Profiles

Sudden drops are OK when you want them, but steady oscillation is wanted sometimes. Here, we see the sudden-drop cam and next to it the same-size cam but made for smooth action.

This is a diagram of the cam. See how the profile (red) relates to the circle and center. The circle is divided only into four because this is a simple action.

For more complex actions, divide the circle into more parts.

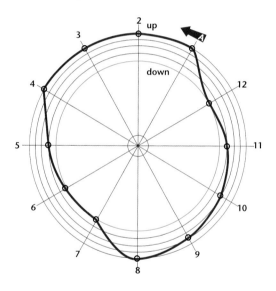

HELP

What happens when it gets more complicated?

More complicated ideas sometimes mean more complicated mechanisms. Designing cams is a satisfying task. Scribe a circle at the highest point of rise (shown above in magenta) and a circle at the lowest (green). Draw a few equal concentric circles between the high and low (gray). Plot the high (1–4 and 8) and low (6, 7, and 12). Join the points with a smooth line, using the concentric circles to help you get a nice gradual line. This is a very rudimentary lesson—I recommend a little reading. Machinery and drafting technology books will give you more and better information.

Dividing Circles

Much of kinetic art involves rotation, so knowing about circles is useful. The line extending from the middle to the outside of the circle is called the radius (r). If you step off the radius around the outside of the circle (circumference), it goes six times— always!

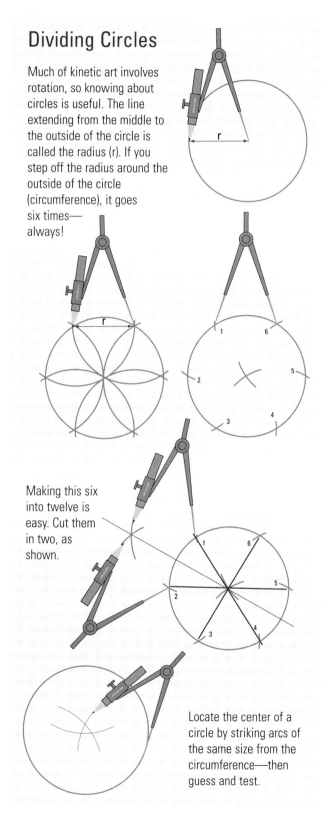

Making this six into twelve is easy. Cut them in two, as shown.

Locate the center of a circle by striking arcs of the same size from the circumference—then guess and test.

Drum Cams

A simple way to get action in your toys is with a drum cam.

Drum cams are found in music boxes.

Drum cams are adjustable, which makes them very useful.

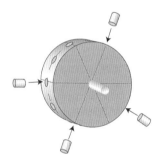

Drill holes around the outside of a disk or wheel. Insert pegs to create the upward motion. These pegs may be moved or lengthened or shortened as you progress with the design and construction of toys.

Several drum cams work together in a gang for different actions from the same shaft.

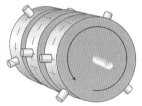

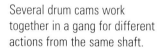

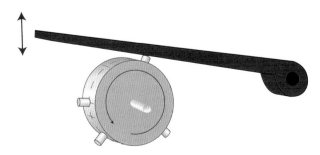

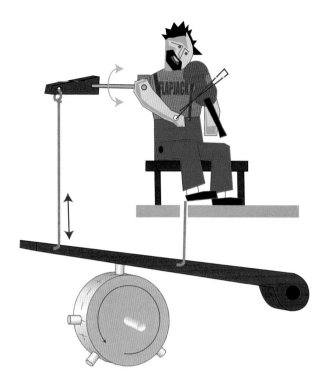

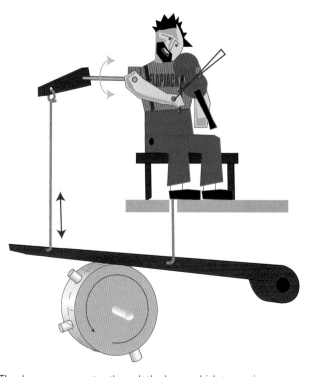

The pegs can activate anything. A simple device is to make them operate levers, which are linked to other things—like this fiddler's arm and foot.

The drum cam operates through the lever, which transmits movement through a wire connector. The fiddler's arm rotates by way of a lever. The foot stomps in time to the music.

10 Blues

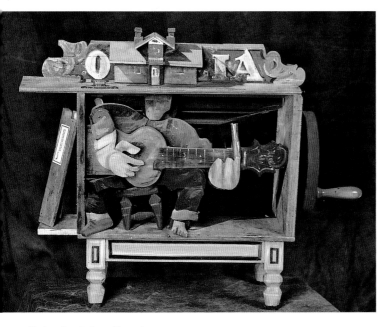

Trains Don't Stop Here Anymore,
So I'm Laying Down Some Tracks.
Collection of Gord and Jane Ball.

Man, sometimes you just get inspired! When the Blues Festival came to town, I made this piece. It's simple and rugged, just like the blues—a little rough around the edges, but real and historic. Blues guys sing a lot about trains, so I included the local train station, even though no trains run there anymore.

I had first made a drawing of a guitar player. It was just an atmospheric, heavy-pencil drawing. His hands were big and his head was small, and he had one foot bare, because the week before, I had been to a concert and the singer took off one shoe and said he felt better that way. Then I thought it might make a nice toy and show a bit more of how I felt.

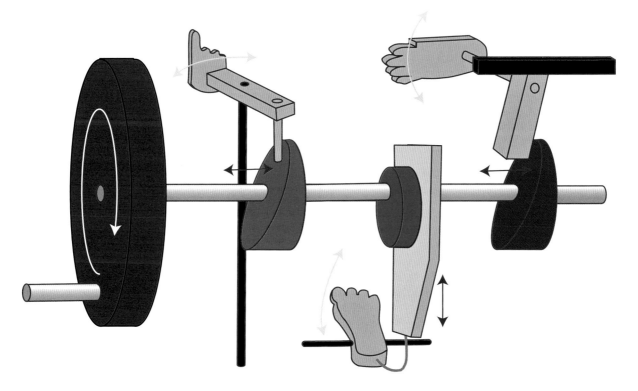

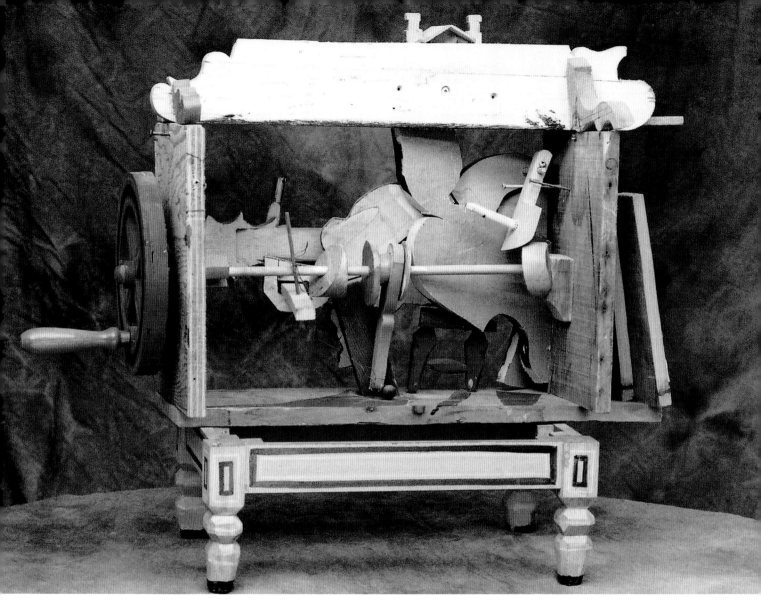

How It Works

The diagram opposite shows how simple this toy really is. One shaft carries everything—two side cams and an eccentric.

The blue cam pushes a lever sideways to move the guitarist's fingering hand. The purple cam moves a pivoted lever to the strumming hand. The green eccentric operates the tapping foot.

This diagram is very schematic, and you will need to work out the balance of all these pieces by trial and error. The red flywheel ensures smooth and easy rotation.

I made the guy and the guitar and put them in an old whiskey crate.

I animated everything from one shaft. I put a heavy flywheel handle on the side. It's like the kind on the mangle (a hand-turned clothes-dryer) my mum used (or made us use, I should say!). The wheel drove a shaft that had some side cams on it, and his foot is driven by an eccentric cam.

Then the train station idea came along and the title *Trains Don't Stop Here Anymore, So I'm Laying Down Some Tracks.*

11 | Wiggling Eyebrows

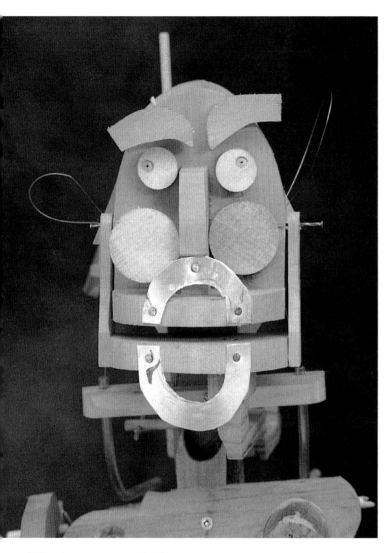

When I saw someone wiggling an eyebrow, I wondered how to make that movement. One thing led to another and I ended up with this face.

When creating something, we have only an inkling of what it will be and what it will look like. This is the difference between working from drawings/plans and working empirically.

Drawings are for telling *someone else* what you want to do. When you work by yourself, you don't need drawings. Drawings lead us away from seeing and knowing what is actually happening. Working from drawings leads us to make what we thought would be good, not what is. When we work from drawings, we tend to exert our will and expectations, paying little attention to what is actually before us.

Follow Your Sense of Intuition

Before shopping, we often make a list. We note what we want—tomatoes, mushrooms, etc. No further details are needed. If we make a more comprehensive list, including the exact color of the tomatoes, for example, we will have difficulty, because the reality is that, today, the tomatoes are a slightly different color from the expected. So it is with detailed drawings—because they are rigid, they don't allow for anything unexpected. In other words, they stop discovery.

Finding our what works by making, doing, and discovering is called the *empirical method:* experience, trial and error, observation, and experiment. When the gods created the world, do you suppose they had drawings? If not, what did they use? If they did have drawings, what became of them?

Yet drawings do have their uses in making kinetic art. In addition to helping us explain to someone else what we need, drawings can be very useful if we have a complete understanding of the project. After gaining a little knowledge, we also can use drawings for sorting out complications. And they are useful for helping us to remember certain things.

Making A Wiggling "Eyebrow"

Make a piece like this diagram. Use ¼-inch-thick material. The hole is ¼ inch.

Put a piece of ¼-inch dowel in the hole.

Twirl it between your fingers.

Don't worry about what it is—we can change that later. Now we must support it with something. Next I'll show you what I did.

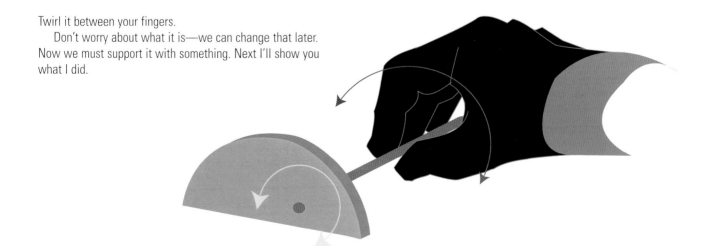

Supporting the Moving Piece

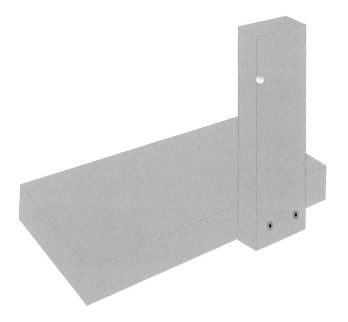

Take a piece of 1-inch pine.

Drill a hole in one end. We are going to put the dowel into this hole, and we want it to revolve freely, so make the hole bigger than ¼-inch diameter. Make the hole bigger by using a ⁵⁄₁₆-inch bit. Or use a rattail file to ream out the hole.

Now take a piece of pine for a base. Screw the upright to it.

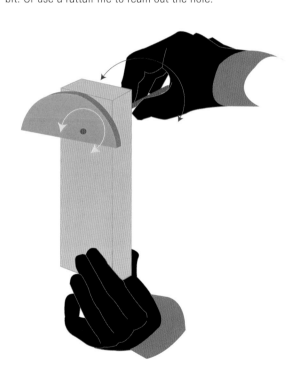

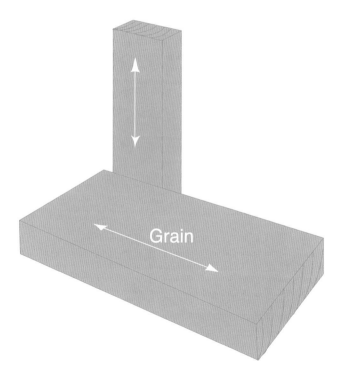

Put the dowel through the hole and twist the "eyebrow."

Notice how the grain of the wood goes in the long direction.

Testing the Action

Put the dowel through the hole in the upright.

Twist it. See the action that we had.

Put in two screw eyes. They are medium screw eyes.
Will they take a ¼-inch dowel through them?
Check this.

HELP

What is grain?

Grain is the pattern reflected in the structure of wood. Trees grow in layers—every year, there's a new layer. These layers are alternately hard and soft. The hard is dark; the soft is light-colored. You can see them in wood. The direction of the grain in a piece affects the strength of the piece. Generally, we have the grain running in the long direction—that is, *along* and not *across*.

You can learn more about grain by reading woodworking books, talking with someone who knows about grain, and by fiddling with pieces of wood yourself.

Files and Abrasives

Rat-tail

For making adjustments to wood or metal, files are good to have around. A file is a piece of hard metal that has many small teeth on it.

There are several different types. Some files have round backs, some are round, and some are square.

It is useful to have a medium half-round file and a small round, or rattail, file.

Files are expensive to buy new, but you can get them at garage sales cheap. To check to see how worn it is, put your finger on the far end and run it down the file toward you. If it "bites" (feels roughish), buy it—if it's cheap!

MEDIUM

Half-round

Sandpaper is no longer made with sand. Get Garnet paper/80 grit. The higher the number, the finer (smoother) the grit. You'll find that 80 wears out and becomes finer, so don't go beyond 80!

Files get clogged up and won't cut. To clean out a file, use a file card. A file card is a small flat wire brush. It looks like this.

Adding a Block and Skewer

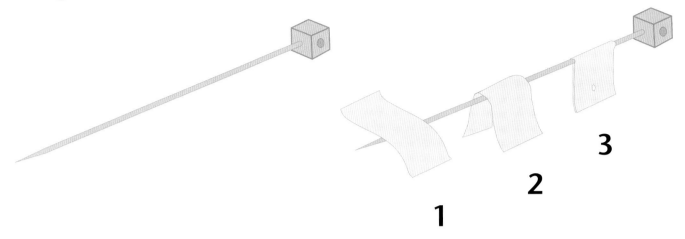

Take a small block of wood. In one side, drill a ⅛-inch hole. Glue in a meat skewer. Drill a ¼-inch hole through the block and skewer.

Add some masking tape tabs to the skewer. Punch a small hole in each.

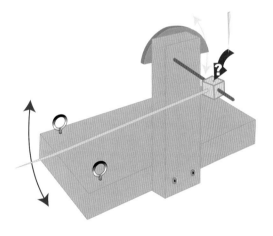

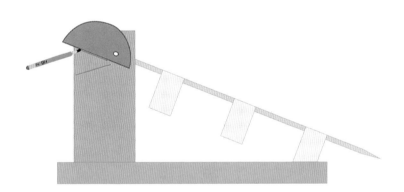

Put the dowel, eyebrow, and stand together; then add the skewer with the block.

Twist the dowel at the back, and see both actions (eyebrow and skewer).

If the block rotates on the dowel, drill a tiny hole through both the block and the dowel and insert a toothpick.

Mark the high and low. Experiment with moving the skewer up and down using the tabs. Notice how the tab closest to the eyebrow moves only a little but the one furthest away moves a lot.

HELP

It is important to feel within yourself the movements and the effort involved. This is something that is not measurable, nor exactly describable.

The feeling may be pleasurable or it may not be.

If you are wondering what I am talking about, then answer me this. When you stroke a cat, how much pressure do you use? What is the feeling you get from the cat's fur? When the cat jumps from your lap, do you notice the effort as it leaps away? When you come to design your own pieces, this is how you work.

Adding to the Mystery

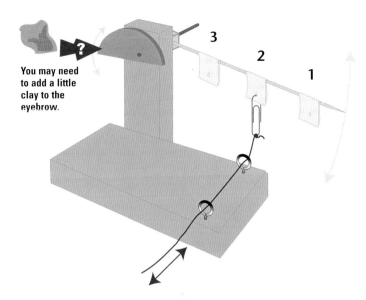

You may need to add a little clay to the eyebrow.

We can, of course, operate the skewer by hand, but an extra step adds to the mystery.

Tie some thread to a paper clip. Put the thread with the paper clip through the eye bolts. Hook the paper clip to one of the tabs. Here, we have to be conscious of thinking.

Pull the thread to activate the eyebrow.

Notice the distance that your hand travels in relation to the eyebrow and the amount of effort needed to pull. Remember this in your mind and in your body. Remember how it felt.

Now take the paper clip and move it to the #3 tab. Pull the thread. How does this feel?

It actually takes more effort to pull tab #3 than tab #1.

Here is a diagram to show how, even though you move your hand less, you have to put more effort into it.

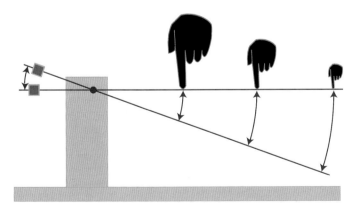

Introducing a Crank

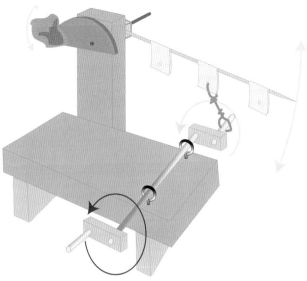

Pulling on a thread is one way to activate the eyebrow, but a little more mystery and excitement can be added if we make a crank. (To learn about cranks, see the next chapter.)

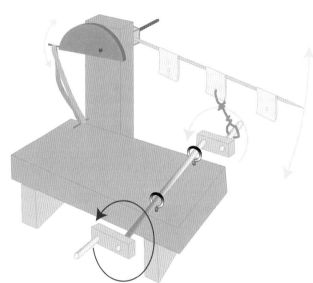

Instead of clay, you can use a rubber band on the eyebrow. You'll need something!

12 Cranks

Turning circular motion into straight motion and turning straight motion into circular motion are what cranks do. Cranks are levers that go around. A crank is a lever on a stick.

There are a lot of ways to make a crank, and you can improvise on these later, once you have grasped the principles. For now, I'm going to show you some simple ways to make cranks.

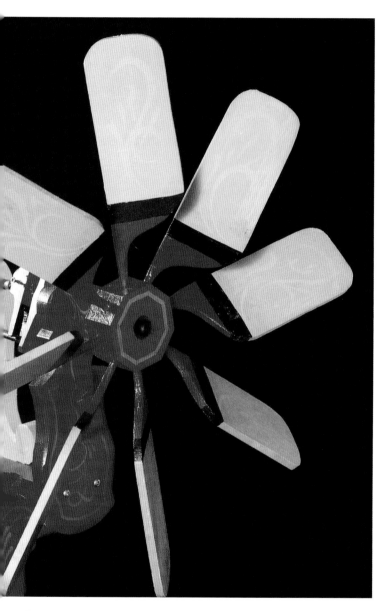

The propeller on a whirligig is a crank too. The wind acts on the blade just as your hand would when turning a handle. Try this: Put your finger near the center of the propeller and turn the machine, and then gradually move your finger further out to the end of the blade, turning all the while. It becomes easier to turn, doesn't it? Why is this?

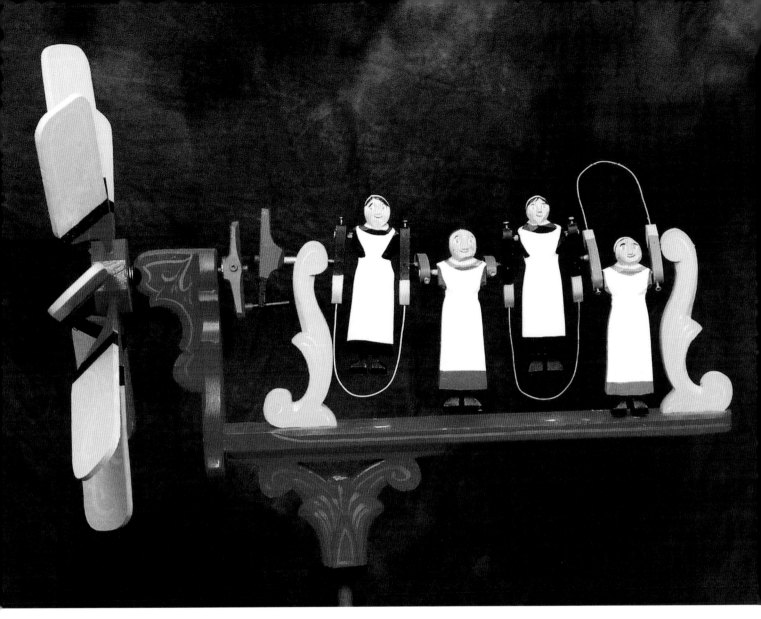

New Day, Old Ways by Rodney Frost. *Collection of David and Evelyn Pollock.*

New Day, Old Ways is a wind-driven shaft full of cranks. When we build a double crank, we usually put the cranks opposite each other on the shaft to help the balance and to distribute the effort. With more than two cranks, they are put at intervals around the shaft. This creates a more smooth rotation.

Make sure that the shafts at each end are in line when you use a shaft with a crank—a crankshaft.

Notice the offset crank between the propeller and the drive shaft. Use an offset crank when the drive and the shaft are not in line. Offset cranks are also nice to look at.

Simple Cranks

Take a small piece of wood about ¼ inch thick and a couple of inches long. Drill a hole at each end. Insert some ¼-inch dowel—a short piece and a long piece. You want the dowel to stay in the holes; a dab of glue will ensure this. You now have a simple crank.

When working on a piece, make simple cranks and handles like this to help turn your machines. Later, make a nice handle.

You can get a disk of wood (make it or buy it) and drill a hole in the center if it hasn't already got one.

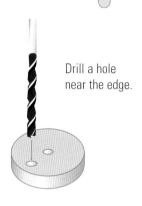

Drill a hole near the edge.

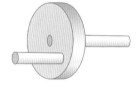

Insert dowels into the holes.

Hold one dowel in one hand and the other dowel in the other, and twist it around. Feel good? You bet!

Welcome to the crank world!

Supporting the Shaft

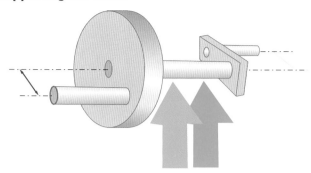

A crank is a type of lever. More about this follows later, but for now we have to support the shaft. That's what the green arrows indicate.

Power is transmitted through the shaft. Cranks can be long or short, depending on what we need to get the action we want.

Cranks turn shafts. Often we can support the shaft through part of the artwork, as when we made the "eyebrows" in chapter 11. When this is not possible, make a pillow block. Drilling straight is important, so use a drill press or be very accurate. If you don't have a drill press or you need to put the shaft in from the side, make a two-piece block, shown on the right. Saw out the slot and clean it out with a file or chisel.

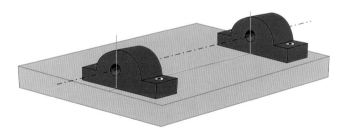

Pillow blocks screw down to the base. They must line up.

Securing the Pieces with Screws

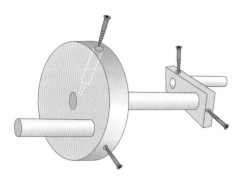

We don't know what changes will be needed as we work, so fix the shafts and crank pins with small screws. Notice how, in the disk, the hole for the shaft screw is a little larger than the head of the screw for most of the way in—make sure to leave enough wood for the screw to bite before it meets the shaft.

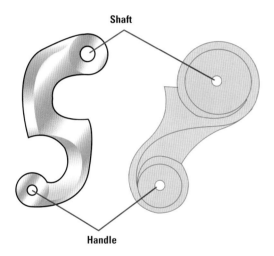

Shaft

Handle

These handles are carved from medium density fiberboard (MDF), which can be shaped easily.

Hardware

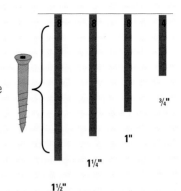

3/4"

1"

1¼"

1½"

Screws
Working mostly with 1-inch wood, I use the four sizes shown on the right. Keep old screws, though some you will have to buy.

Finishing nail (L), Common nail (R)

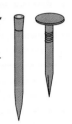

Nails
It's handy to have a few 1-inch finishing nails. Others also could be put to good use, but generally, pounding in nails is not convenient for this kind of work.

Washers
A selection of washers is good to have. Take a piece of the dowel that you are using to the hardware store and test the hole—reality and inventory do not always agree.

Screw Eyes and Bolts
The screw eyes have a screw end, and the eye bolt has a bolt end—you will need washers and nuts for them.

Metal Rod
This is the metal equivalent of dowel. Steel and brass can both look nice, depending on your needs.

Tubing
Hobby shops carry a good selection. It comes in metal and plastic. Tubing is good for lining bearings. Tubing will slide one size into another, useful for achieving some effects.

How a Crank Works

A crank is a form of lever. It transmits power. Cranks convert circular motion into straight-line movement (reciprocal motion).

Here are three diagrams of a crank. In all the pictures, the handle, or input, is the same (red arrows), but the crank, or output, is different (blue arrows).

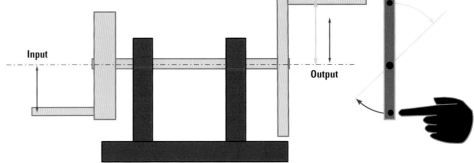

In the top diagram, we see that the handle has a shorter throw (swing) than the crank. This means that we will get more movement from the crank per revolution but need a little more power to do so.

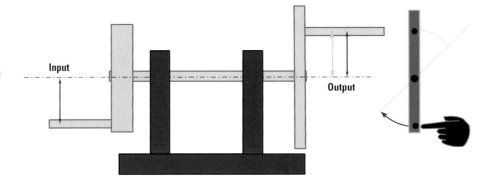

The middle diagram has an equal handle and crank swing: The same amount of power and movement in as out. The movement of the handle is the same as that of the crank.

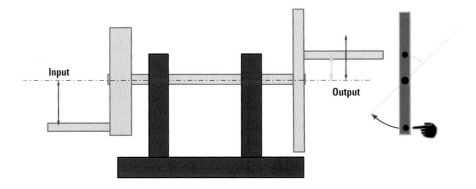

The bottom diagram has a larger throw on the handle, and so we have an advantage over the output.

The blue bars represent levers with pivots (black dots), giving another explanation of crank workings. *Load* has a lot to do with your decisions about cranks. For example, with a small load but a good distance to move, the top example is fine. It's a matter of figuring out what you want to do and how. The information on this page may help you later if you are looking for ways to improve your piece.

Making a Number of Cranks

When making a crank, the difficult part is keeping the shaft in alignment. This is what I do to avoid shaft problems. This works for any number of cranks.

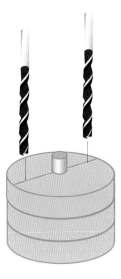

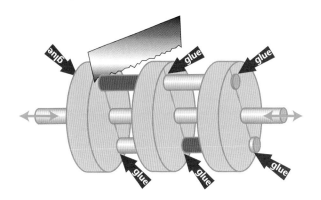

Take three disks with center holes for the shaft.

Drill holes through all the disks together.

Glue the crank pins. Do not glue the shaft! Allow the glue to set. Saw out the parts of the crank pins that are not needed.

Shaft

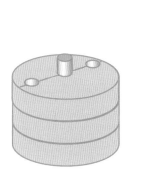

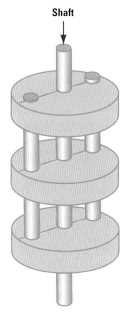

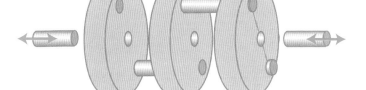

Insert the crank pins and shaft. Check for alignment.

Later the shaft can be inserted. Secure the shaft with screws, glue, or whatever works best for what you are doing.

13 Shafts

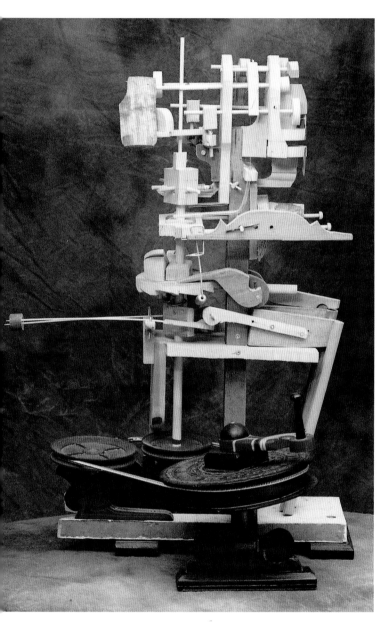

Total Sensation Man by Rodney Frost.

Shafts are the center of making movement. Shafts can be any size that you want. They need to be straight. Shafts carry the motion and must be strong. They can be made of any firm material—wood, metal, Plexiglas, or plastic—there are advantages and disadvantages to each. Shafts can be installed in any direction you want—up and down, side to side, or at an angle.

As long as the bearings and shaft are in line, it will turn. When the bearings and shaft are not in line, it will not turn. Look at the shaft from the front (it should be in line), from the side (it should be in line), and from the top (it should be in line).

Shafts can carry one thing, such as a crank, or they can carry many things, like cams, pulleys, cranks, and levers.

Strain on Shafts

As your art piece grows, more weight is added and so more strain is put on the machinery. Shafts take a lot of this strain. The shaft and everything on it take pressure from the parts they contact. Shafts really have to endure a lot. In addition to the side-to-side and up-and-down weights and pressures, there is another stress called torque, which means circular strain. Torque is not something we have to worry about too much. But when we are using dowels as shafts, it can be a problem—and its effects don't show up until far along into the construction of our empirically created piece.

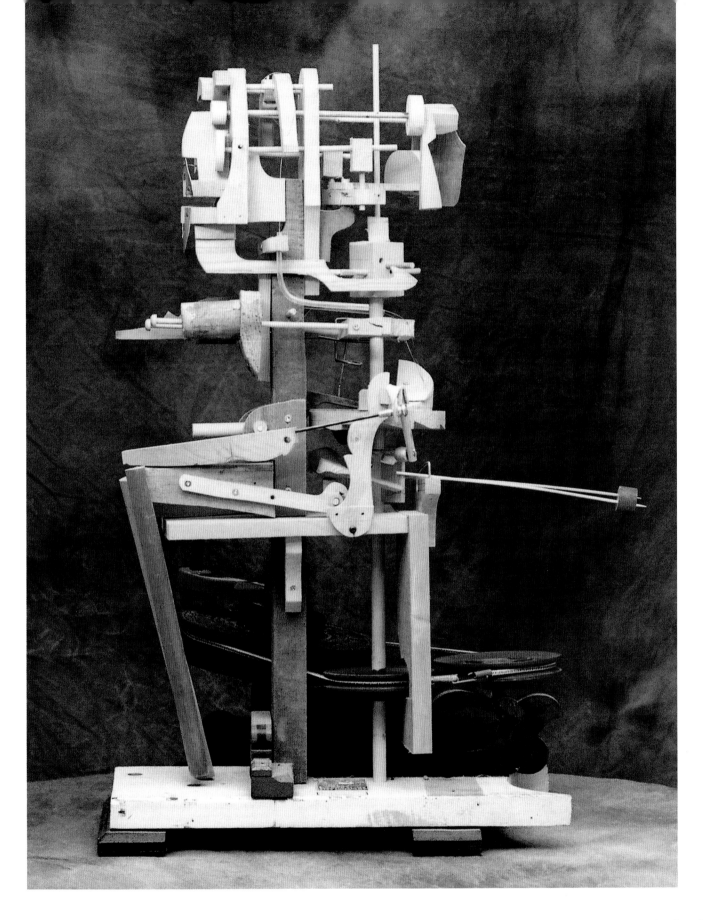

Supporting Shafts

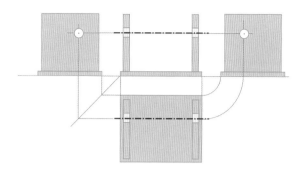

Shafts must have bearings that line up. In other words, they must be in a straight line. Look at your shaft from all sides to make sure it is true.

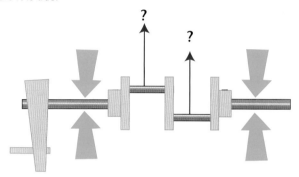

Shafts need a good support. Weak and wobbly bearings and supports don't fix themselves. Maybe you'll have to go back and make some changes when you've decided what you need to make your motion manifest. Don't worry or get angry—making changes that might be improvements is part of the empirical method!

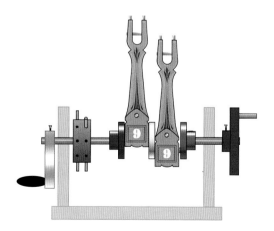

This shaft has been made to take several different items—a handle, a drum cam, two cranks—each with a pitman (another name for a connecting rod) and an outside takeoff. Which is which?

Calipers

Outside **Inside**

Measuring the inside or the outside of round (or flat) objects is easy to do with calipers.

The calipers on the left are for measuring the outside of an object like a dowel. The pair on the right is for measuring inside dimensions such as for holes and spaces.

The calipers below take both inside and outside measurements. When you open one end, the other end is the same size. They're very useful.

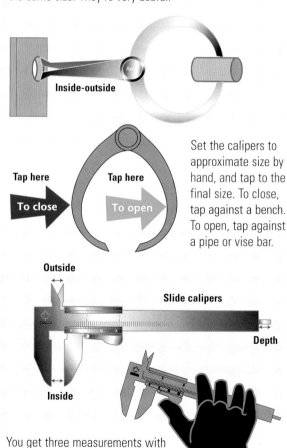

Inside-outside

Tap here
To close

Tap here
To open

Set the calipers to approximate size by hand, and tap to the final size. To close, tap against a bench. To open, tap against a pipe or vise bar.

Outside

Slide calipers

Depth

Inside

You get three measurements with slide calipers. They are easy to find in hardware stores, and cheap plastic ones are all you need.

Attaching Items to Shafts

Items are generally attached to the shaft with screws. Wood will indent and keep the item from slipping. When using metal, file a flat spot where the screw will be.

When the shaft turns, it will twist a little (green arrows). This is because the load—your cams and propellers or whatever you have put on the shaft—will want to stay still (red arrows). If there is enough force, it will turn. A twisting, or circular, force is called torque.

Thin shafts made of wood will sometimes split and splinter, and you have to make a choice: reduce the load, increase the diameter of the wood shaft, or change to another material, maybe metal.

HELP

What happens when it gets more complicated?
Check the assembly for obstructions. Check that the bearings and shaft are in line. Test the alignment of the bearings with a stick of the same diameter as your shaft, and see that it turns freely. Check that the shaft is straight. Be sure (especially when you have a crank) that the shaft ends are in line.

Listen to the sounds and follow them to find problem areas.

Offset Cranks

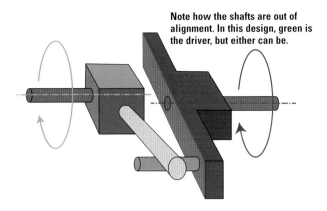

Note how the shafts are out of alignment. In this design, green is the driver, but either can be.

There will be times when shafts from one action won't line up with another. This is what I call an offset crank—it is actually two levers working with each other. One configuration is shown here, but there are many. As long as one pushes the other—that's what is needed.

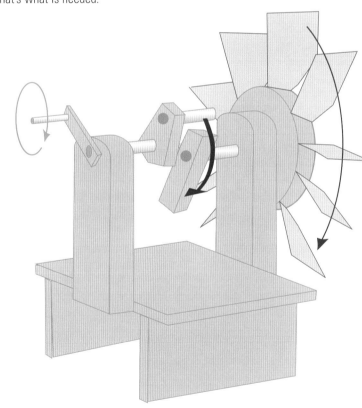

The project, in this drawing using an offset crank, should be within your range of understanding and skills by now. The propeller will blow a breeze to someone, in which case we'd call it a fan. Of course, the fan, if the wind caught it, would be the propeller and turn the crank. Offset cranks work both ways!

14 Slots & Slides

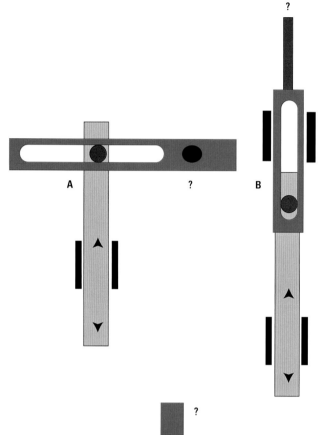

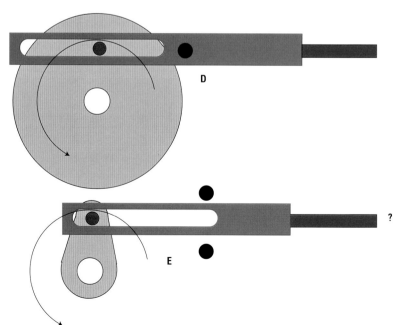

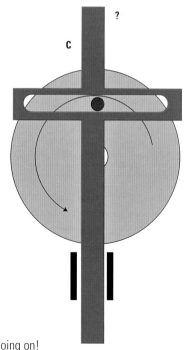

We're getting to a point in our development now when we need a little bit of information without having an idea to go with it. When it comes to kinetic art, information gathering is a historic experience.

Before the electronic age, we lived in the industrial age. There, everything was levers and cams and pulleys, and we could see what was going on.

Most of this stuff appears as drawings in old books. There are thousands of books with pictures that show machines and how they work. *507 Mechanical Movements* by Henry T. Brown is a good one. It was published originally in 1886. There have been several reprints since then. You can locate a paperback edition published in 1995 with the ISBN 1-8793-3563-8.

Lots of stuff going on!

Can you figure out what's happening here?

A Reciprocating motion is turned into back-and-forth movement on an axle.

B Reciprocating motion remains, but at each end of a stroke, there is a pause, or dwell.

C Rotary motion becomes reciprocal motion. In this example, it is vertical.

D Rotary motion becomes to and fro.

E Rotary motion to elliptical, with a dwell, or pause, at each end of the stroke.

F Rotary motion becomes to and fro.

G Both ends become to and fro.

H The dwell can be achieved by pegging the slide. This is good for experiments—a series of peg holes will show different dwell.

I This works from both ends— reciprocal to rotary or rotary to reciprocal—with dwell.

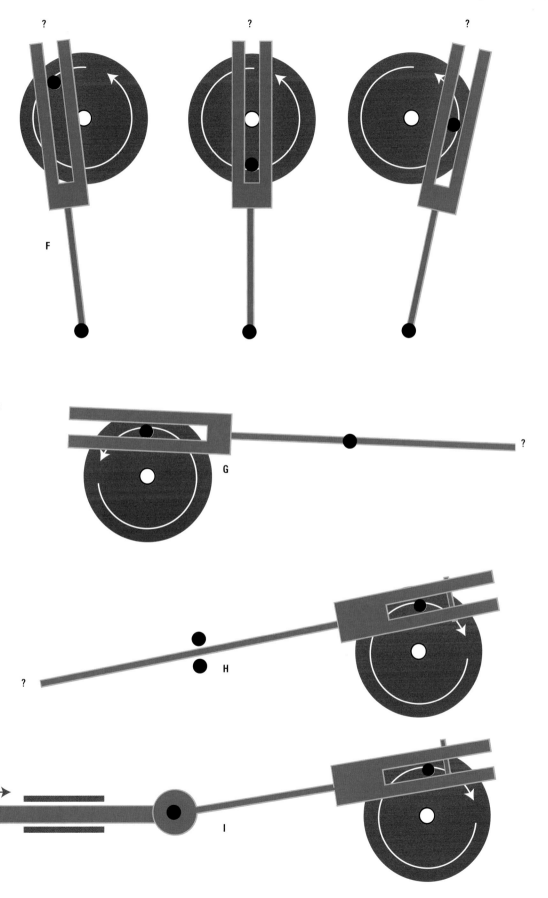

15 Drawings

I rarely do drawings before I begin a project. I find that the materials I am using and the movements I want to create are much more real and exciting than a drawing. Following a drawing is just a slavish chore. This is quite the opposite of what is taught in schools: They say—make a plan, draw an outline, and get it approved by the teacher. Wrong!

I make a drawing to get the gist of the idea and anything else that may occur. I have an idea of the piece in my head. Then I start to work with the materials, and they tell me what can be done—what will work and what will not. What is in front of me overrules any pictures that I have on paper.

Working Out Difficulties on Paper

On these pages, I have shown some of the things that I intended to build but so far never have, and some that I have built with nothing but a scribble, if that.

However, during the work, if or when I run into difficulties while building a project, I will try to work them out on paper. Some of the solutions have been so complicated that I never implemented them (but I still might!). Often I think I have worked something

The *Total Sensation Man* started as a study of eyebrows (top). Then I scribbled down some notions on how it might be supported. The first title was *The Eclectic Chair*—titles help, but don't set them in stone.

out, and go for it, but the materials tell me otherwise. Nevertheless, the work I did on paper had got me around the original blocks.

Surprise Yourself

As to the actual building of a piece, I start at the top and work down. The action is the most important thing. Determine the action and then build to support it. Build your idea as you go along.

Let your action and materials tell you where to go. Surprise yourself. This is where a good sense of history and styles can come into play. Consider a variety of images—religious, cultural, mythical, musical, mechanical, and so forth. Themes and possibilities will suggest themselves—be open to them.

By doing things this way, you will become an artist, and nothing will or must be outside of your realm. No field can be proscribed except by you.

If you want to be an artist, get information and turn it into knowledge.

So far I have not built this toy, called *Lumberjacks on the Big Fiddle*. I had a good time thinking about it. I had a great time drawing it. I loved telling people what I had in mind and what I was going to do, but I never built it. Someday I will—yeah, sure.

The drawing and all the talk and hope are, in themselves, complete and go no further.

But I will make it someday. . . .

Drawing for *Lumberjacks on the Big Fiddle*.

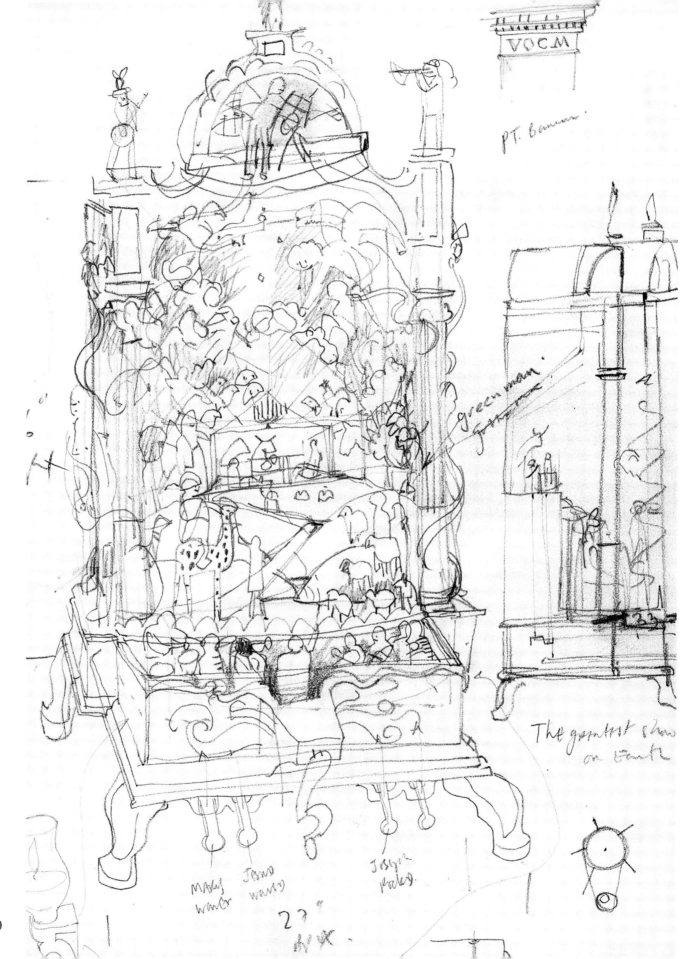

VOCM

PT. Barnum.

green man puppet.

The greatest show
on Earth

MARY
wants Jesus
 wants

Joseph
pulls.

2?

Where Ideas Come From

Current events or past events are a good source of inspiration. A little twist of the brain box will get you some interesting results.

I once did a great many drawings for a piece called *Kavorkian Manor*. The pun of manor/manner got me thinking about the building and people jumping off— a game.

In making the piece, I was having difficulties getting the people up to the top floor. I made several attempts, but kept referring back to the drawings, which didn't help. I've got a lot of drawings though— just like everyone tells you to make for a successful project!

I was making a sailing-ship clock when I gave myself a nasty cut to my hand. I was tired and should have quit working, but you know how it is—you just must get something done! When I came back from the hospital, I was kind of soured on the sailing-ship idea and turned the whole thing into the *Titanic Sinking* toy shown on page 82. I used no drawings for it either.

The *Act of God Theme Park* has no drawings—not one, before or after. I just built it. If you can do a drawing, you can start building right away.

Il love this *Nativity* scene. Have I made this magnificent, well-planned piece? Nope!

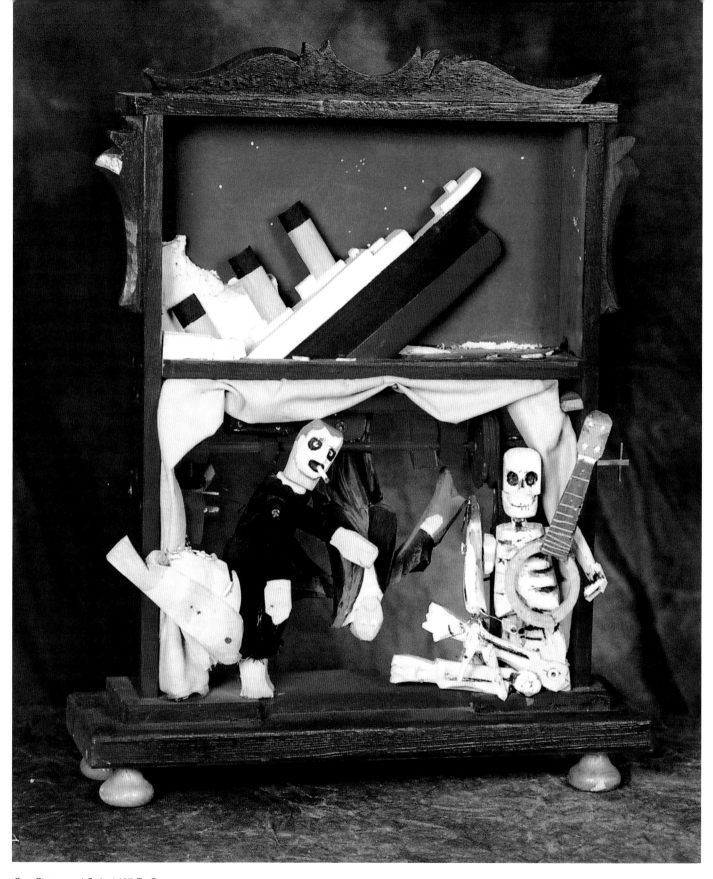

One Down and Only 1497 To Go.

MAKING MECHANICAL MARVELS

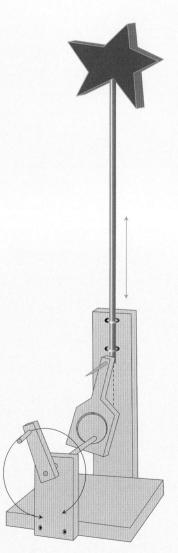

16 Star

Start with a star or some other shape.

ost of our engines and motors produce circular, or rotary, motion. Sometimes we need to-and-fro, or reciprocal, movement. Let's see if we can create that.

Come to think of it, we don't have many movements—at least, movements we can name. Move your arms around in the air as if you were doing a dance. How do we describe those movements? If we had to write them down, we would probably describe these wonderful arm motions using words like *up* and *down* and *around*—words that we have. We have other words like *swing* and *swoop*, but even if we put them all together, they would not accurately describe your arm dance. We can only describe things with the words we have.

Some cultures have just three words for colors: brown-black, yellow, and white. How would they describe a rainbow? How do we describe a rainbow? Seven colors? Look at a rainbow and name as many colors as you can, and then count them.

The seven colors that most people say are in the rainbow are what I call *colors in boxes*. It's convenient to perceive colors this way, and they are safely in those boxes for most people. We have to feel safe and confident in order to open those boxes. That's why art needs a nonthreatening situation in which to occur. Art is like sleep in many respects (and it has similar effects) and happens when we feel safe.

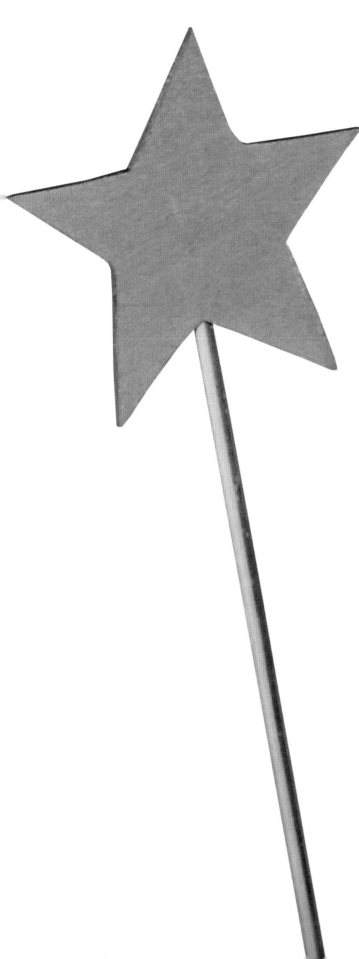

Friction

With rough surfaces, there is lots of friction and extra effort is needed.

With lubricated surfaces, there's less friction and less effort is needed.

You may have noticed already that sometimes parts are difficult to move when they rub against each other.

Even what seem to be very smooth parts will stick, requiring us to apply extra effort to move them. If we look at even very smooth parts, we will find that they are actually quite rough. Sandpaper at a distance looks smooth, but close up when we rub our hands over it, we find it to be rough. The rubbing together of rough surfaces causes friction. We can reduce friction and so use less effort by lubricating the surfaces.

The lubricant keeps the surfaces apart—in other words, stops them from bumping together. Friction is rather like pulling a boat up the beach—it's a lot more difficult to move than when the boat is floating!

Lubricants

I use two lubricants: one before painting and the other when the piece is finished. Oil, the most familiar lubricant, would soak into the wood and make painting difficult. Before painting, sprinkle on a little talc. Talc will make the parts slippery and can either be dusted off or blended in with the paint. Once the piece is finished and painted, use a little petroleum jelly (Vaseline).

Get some of it, on a skewer or toothpick, into nooks and crannies.

poudre
pour
bébés
Acme

Acme
baby
powder

Star on a Stick

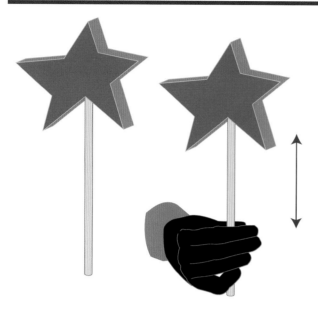

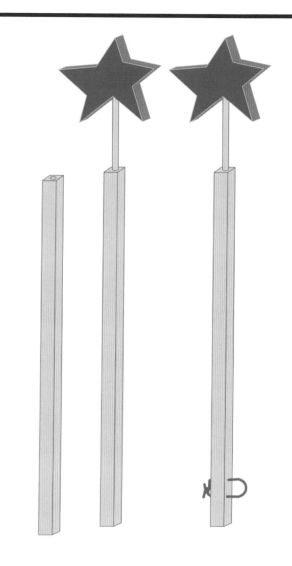

Make a star or some other shape. Put it on a stick. A meat skewer is good for this job. Move the stick up and down.

This is the action we want.

Get a piece of wood about ¼ inch square.

Drill a hole in the end of this stick to receive the meat skewer. Put in the meat skewer—add glue if it's loose.

At the other end, drill a couple of holes to take a loop of wire. The size of the holes will be determined by the size of the wire that you have. Soft wire is good for this.

Make a crank as I've shown. Make it to fit the base and uprights on the right. Make the base and uprights to fit the crank.

Notice the red arrows and green arrows. The red arrows show the swing of the crank, and the green arrows show that you must have enough space below to clear the bottom end of the stick.

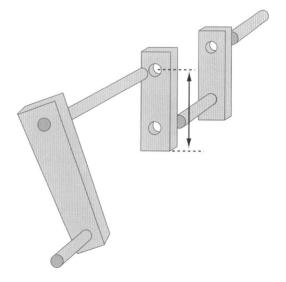

HELP

But which shape should I decide on doing?

Decision making is part of what you need to develop. When you decide on something, everything else falls into place. And if you don't like the way it works, you can change it.

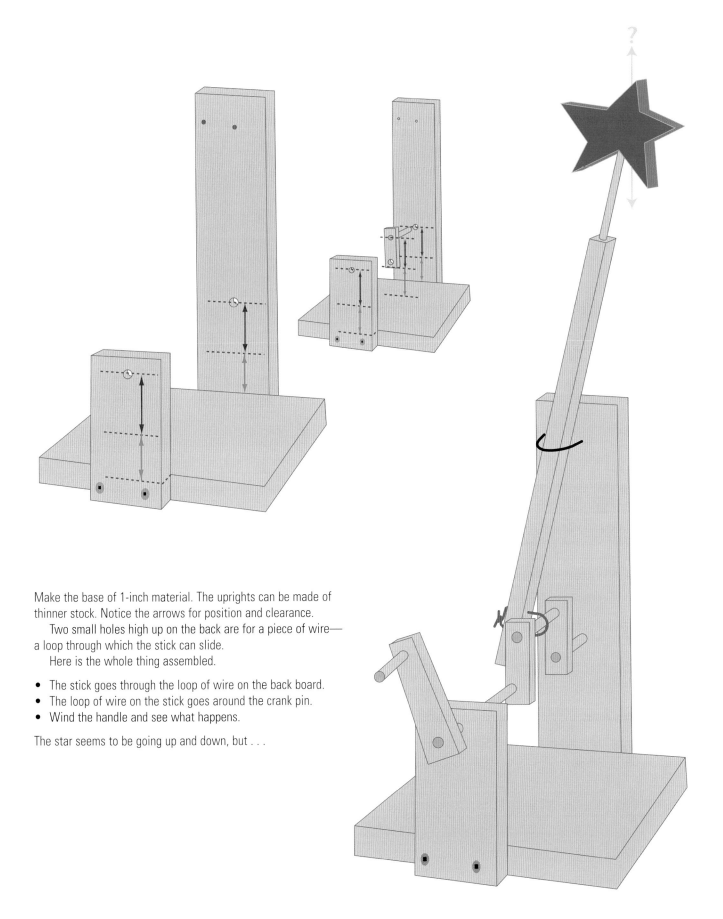

Make the base of 1-inch material. The uprights can be made of thinner stock. Notice the arrows for position and clearance.

Two small holes high up on the back are for a piece of wire— a loop through which the stick can slide.

Here is the whole thing assembled.

- The stick goes through the loop of wire on the back board.
- The loop of wire on the stick goes around the crank pin.
- Wind the handle and see what happens.

The star seems to be going up and down, but . . .

Wood

Most of the pieces in this book are made of wood. Wood is a very accommodating material—it is easy to shape and easy to obtain. We have wood all around us—in doors, windows, furniture, and floors. We can use wood that we find for making other things.

New wood can be bought in several forms that are useful.

Pine—A soft wood and easily worked. Pine planks are available in various grades or qualities. The most expensive is that which has no knots. Cheap grades are fine for our work, as we are cutting out small pieces and can use the wood between the knots.

Specialty—Small planks of hard wood such as oak, ash, poplar, and maple.

Plywood—Made of layers of thin wood, plywood comes in regular thickness and various top surfaces. Generally it's in large sheets, but it can also be bought in smaller pieces, at a premium.

MDF—Medium density fiberboard is excellent for carving and for when you need a flat surface.

Hardboard—Hardboard is very sturdy and smooth. It is made of wood that has been reduced to fibers and pressed together.

Dowel—Round sticks made of different kinds of hard wood. Dowel comes in various lengths and in diameters in $1/16$-inch increments. Kinetic art uses lots of these!

Specialties—Ready-made hardwood shapes can help when you need an especially accurate wheel or something repetitive. Get them at hobby shops and stores that specialize in them.

The Motion of the Star

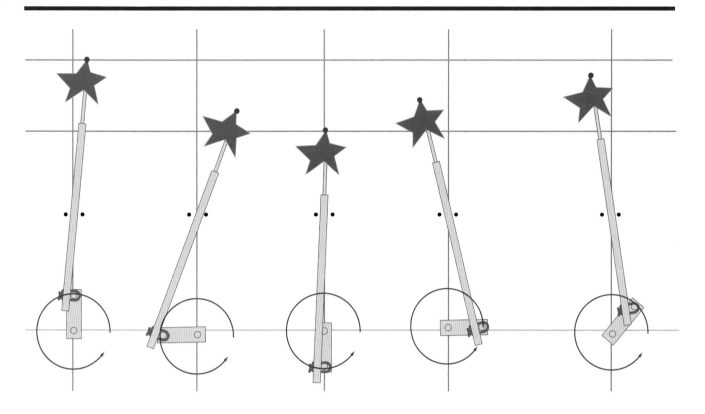

The star is going up and down, but when we look closely, we will see that it is also going from side to side. In the diagram above, there's a red dot on the star to track it more easily. Notice that, because of the circular crank action (which is up, to the side, and down to the side), the star also moves sideways for some of the action.

Sometimes we want this action, so remember it—what it looks like and how to get it.

We can vary the amount of side-to-side action (shown on the left) by changing the position of the loop.

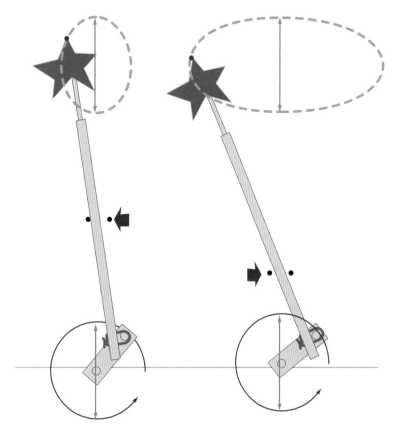

Straight Movement

To get straight movement from circular, we must add a few things to our model.

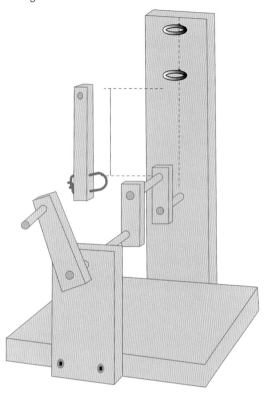

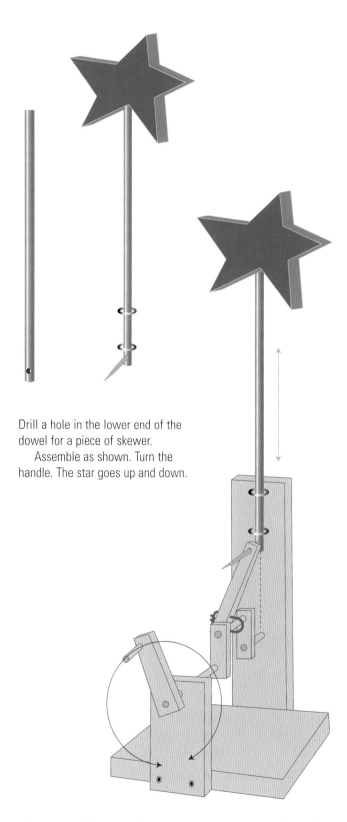

Drill a hole in the lower end of the dowel for a piece of skewer.

Assemble as shown. Turn the handle. The star goes up and down.

Get two screw eyes, or bolts, and put them on the centerline of the back board. Make a star and dowel. The star dowel must be loose in the eye bolts, but not too loose.

Make a short stick with a wire loop and a hole. Note the red line. That's how long it should be. When the crank pin is up, the connecting rod (or pitman, as it is also called) doesn't reach the bottom screw eye.

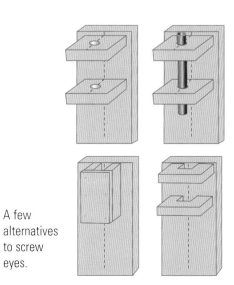

A few alternatives to screw eyes.

You can use this system for movement up and down, side to side, and at any angle in between.

Alternatives to Cranks

Lever and follower

Lever with slide

Cam and round follower

Cam and flat follower

Cam and tension spring

Cam and compression spring

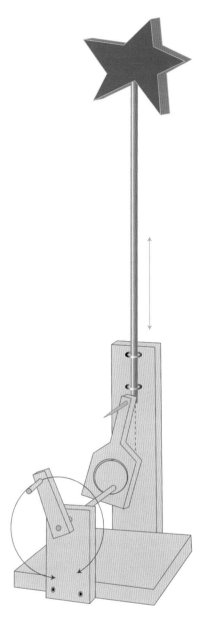

Eccentrics are a delight and mystery to watch. (To learn about eccentrics, see the next chapter.)

17 Eccentrics

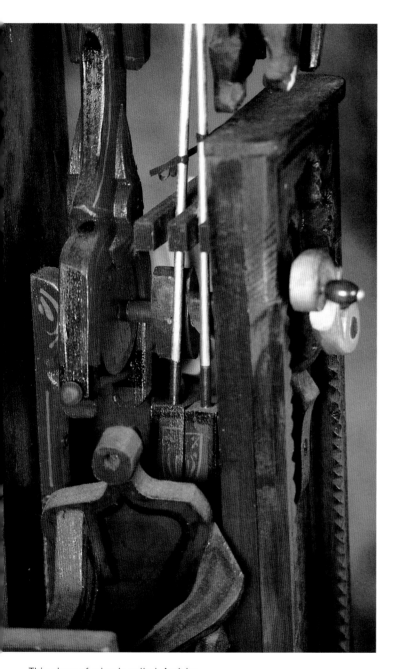

As we work at kinetic art, we realize that it is not just the movement, the action itself that is important, but also the appearance of the machine itself.

The mechanism is also interesting. It is part of our artistic expression. The machine creates the movement. We must be conscious of this as we work and decide which way to make our movement happen.

This piece of mine is called *Activity Without Insight*. The eccentric drives a shaft vertically, moving trip hammers and such. Note the retainer on the yoke.

What is an Eccentric?

We have seen that there are different ways of creating a movement. One of the most interesting is performed by the eccentric, which seems to almost breathe as it revolves around itself. The word *eccentric* comes from the Greek words *ek* ("out of") and *kentros* ("center"). That's what eccentrics are—off-center.

If we take a crank and spin it in our fingers, and instead of using the shaft, we use the crank pin, then we can see the action of the eccentric. The red pointer in the diagram shows how it acts like a cam, pushing up and letting down. The eccentric is a smooth cam.

To make a harness for an eccentric, cut a hole in a piece of wood as shown here. Most times it's more convenient to make the harness, or yoke, open and then close it with a dowel, as in the picture on the right.

You will have to figure out how to keep the eccentric from coming out of the front and back of the harness—it will want to do that.

A small retainer in the front and back is one way of keeping the eccentric in place. A flange on both sides of the cam works well too. There are many other ways you will probably think of and try.

On the next page are diagrams showing the action of eccentrics and cams.

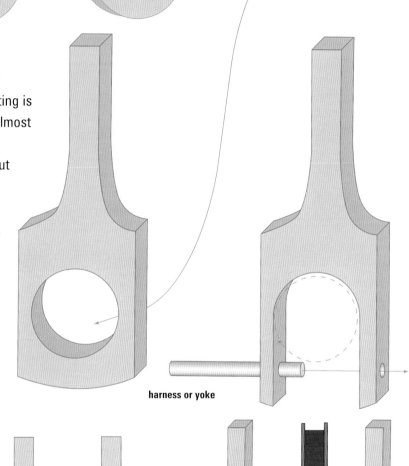

harness or yoke

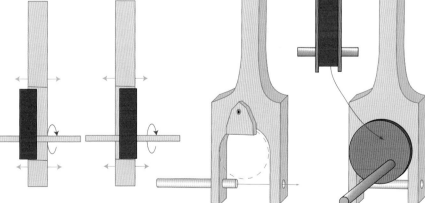

retainers

Actions of Eccentrics and Cams

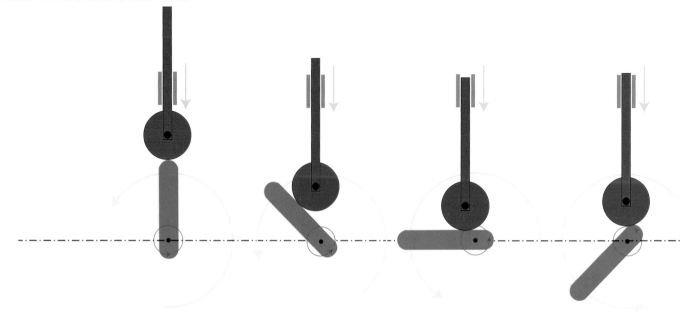

Here is a very simple cam and follower.

As the cam revolves, the tendency is for the follower, and the weight of what is attached, to push the cam down, making the movement uneven.

More or less smooth running here.

The same here.

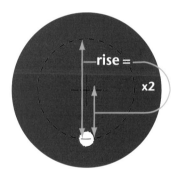

The amount of rise of an eccentric is calculated by measuring the distance from the center to the shaft and then doubling it.

Notice that all these items are shown with a sleeve to ensure straight reciprocating action.

The eccentric transmits power evenly as it works as the cam. A smooth action is created.

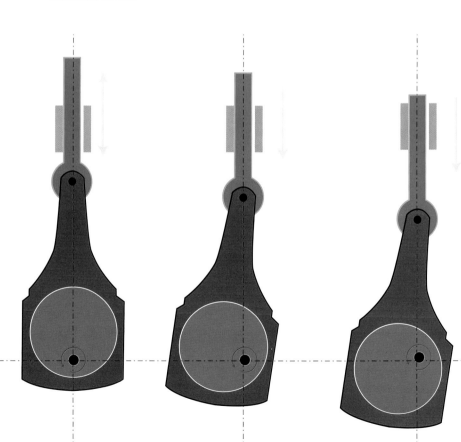

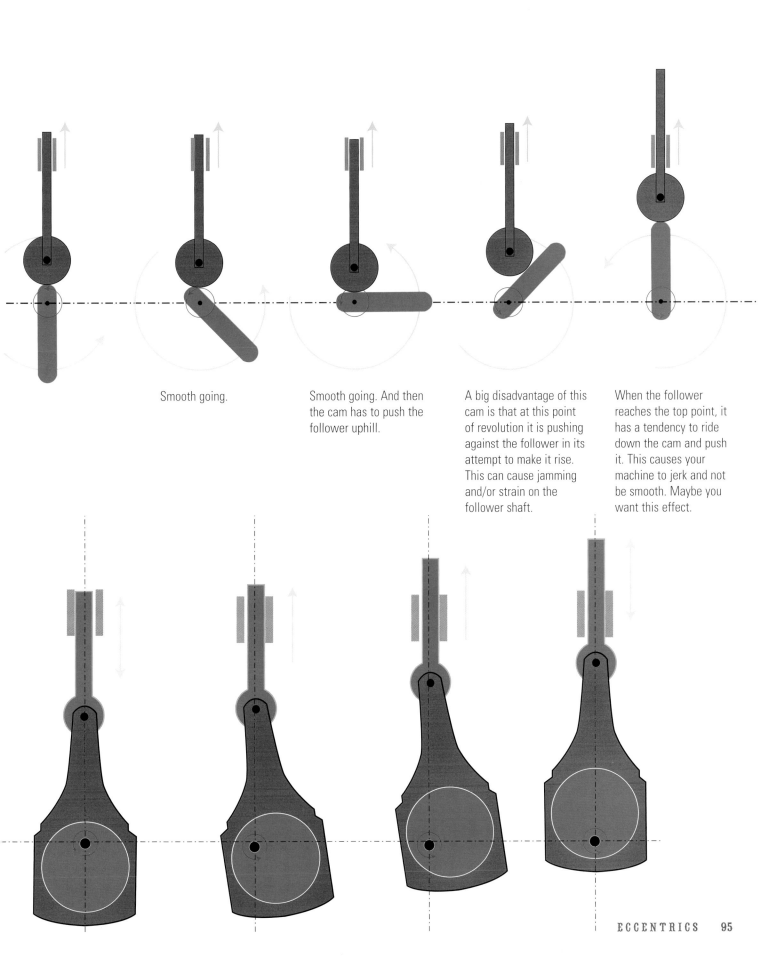

Smooth going.

Smooth going. And then the cam has to push the follower uphill.

A big disadvantage of this cam is that at this point of revolution it is pushing against the follower in its attempt to make it rise. This can cause jamming and/or strain on the follower shaft.

When the follower reaches the top point, it has a tendency to ride down the cam and push it. This causes your machine to jerk and not be smooth. Maybe you want this effect.

18 The Angel

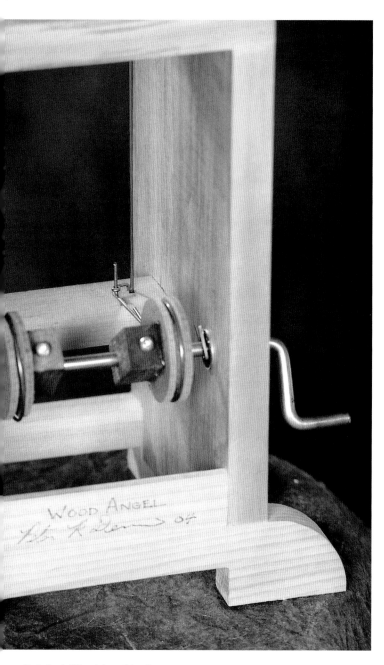

Detail of *Wood Angel*, by Peter
Dennis. Peter Dennis makes games,
and toys, and boats, and furniture.
He lives in Creemore, Ontario.

Two eccentrics operate two levers that
wiggle two pieces of rough wood shaped
like wings; the rest of the structure is nice
and smooth. It doesn't sound like much, does it?

Simplicity is very often the key to a successful
piece. If you show this description to your teacher,
you'll likely be told to put something else in. "Make it
interesting; give it some thought," the teacher will say!

Delight

Peter Dennis, who made this lovely, quiet piece of kinetic sculpture, says, "I make objects that re-create for the viewer, and for myself, the childhood experience of discovery, surprise, and delight in the world around us."

Ah yes, childhood! Even if we had a hard time of it, there were always those moments of delight that were all our own. You know, it's not surprising that children learn so well. They watch and they observe the world around them.

Try doing these things yourself:

- Take a chair, put it near the coffeemaker, and watch the coffee fill the pot—all of it, until it's finished.
- Take a look at a clock with a sweep hand that shows the seconds. Watch the sweep hand go around. Do it again. Does the hand click from second to second, or does it move smoothly? Don't worry about anything else that you have to do—just watch.
- Find some ants; observe them come and go.
- You know those whirling rooftop things that ventilate buildings? Watch one go around for a while, then look at some plants in a wild area.

This is what a child does—all the time, until it's time to grow up from such simple things. Not me, though—and not Peter, that's for sure.

Details about the mechanism are on the next page.

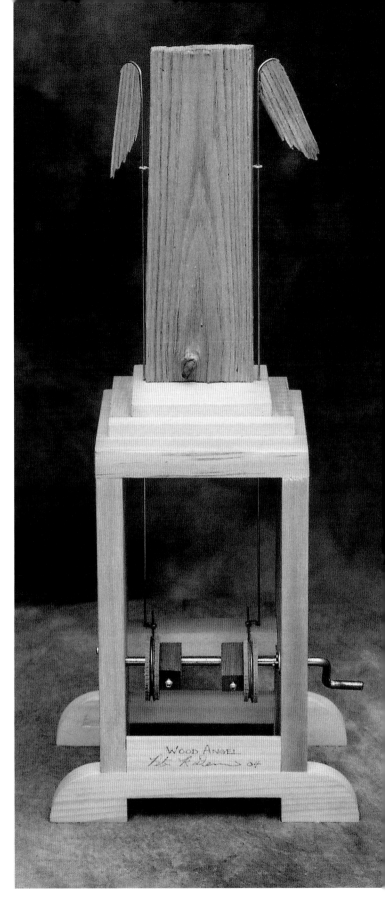

To have some gentle fun with *Wood Angel,* turn the handle. The handle turns two eccentrics. The eccentrics push and pull two levers and rods. The rods are connected to the wings above. The wings wiggle.

Nice, simple, quiet.

Eccentric Cams

Peter's eccentric cams are made of three layers of hardboard glued together. The middle layer is of a smaller diameter to create a recess.

A block on the side takes a screw that holds the cam to the shaft.

After deciding the size of your cam, find a piece of round material that is of a smaller diameter. Bend the wire tightly around the smaller piece. When the wire is released, it will spring to a larger diameter to fit your cam. You will have to experiment with this using different smaller pieces until the wire springs back to the right size.

The pitman, or connecting rod, is made of springy wire.

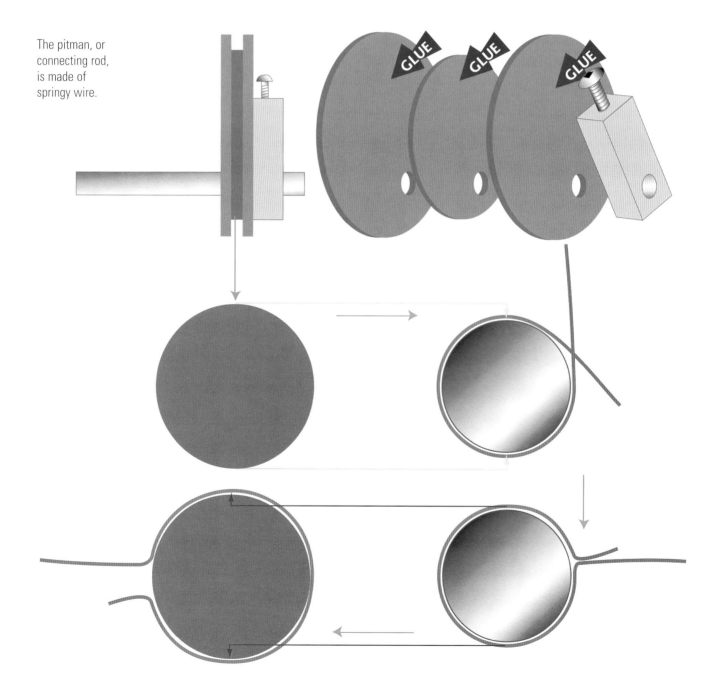

The Wings

The mechanisms that move the wings are very simple. A crank turns an eccentric cam. The connecting rod operates a small lever at the base of a vertical shaft. At the top of the shaft is a wing.

A schematic view of how the wing is wiggled is shown here.

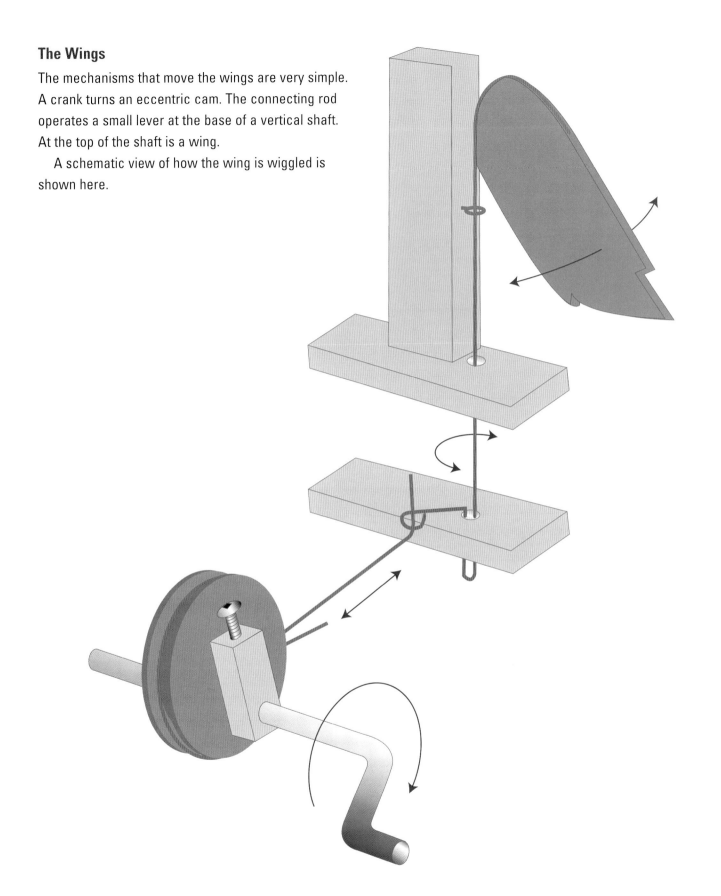

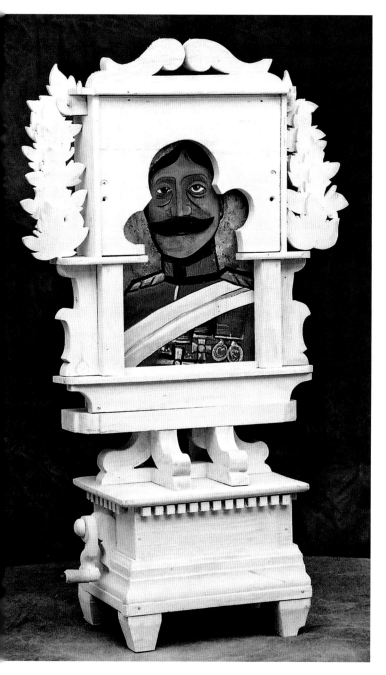

Sam Steele was one of the first Canadian Mounties and a military leader in the Boer War (1899–1902).

When you can see the mechanisms that make kinetic art move, it's fun. When you can't see what makes it move, that's fun too—plus, it's a mystery.

Visit antique stores whenever you have the chance. They are a great source of information and ideas for projects—and mystery. The junk stores with objects that have much of the original dirt and mystery still stuck to them are best—art is not a "sanitary" occupation. Go to auction sales. Get there at viewing time, and stay for awhile if you wish. Look around and get ideas—it's free!

Finding an Idea

One day, in Port Hope, Ontario, I was in an antique shop that was once a chapel (recycling!), and I saw a wayside shrine from Quebec. The shrine was ratty and decrepit, rain-stained, weather-beaten. Once it was venerated—by whom? It was mysterious.

I kept the idea of this shrine in my head for a while, and then the town where I live had yet another celebration of a local hero: Sir Sam Steele.

Sam always looked so serious in his photographs. I could never find anything he'd said that was frivolous. He was a tough guy, though, one of the first Canadian Mounties and a military leader in the Boer War (1899–1902).

Meanwhile, a nearby monastery had recently discovered that they had a portrait that wept. With this "miracle," they saved themselves from bankruptcy by the donations of the faithful.

Having worked for quite a time on arranging the plumbing for a "miracle" of my own, I decided on something more saucy. I had the shrine built, and it was a simple matter to place Sir Sam in it. Photos of his face always showed a big moustache.

Making the Moustache Wiggle

The shrine had a frame that appeared to be free and clear of the base, but tubes ran through the decorative supports. In the tubes were wires to the moustache lever behind the scenes.

My *Sam Steele* always gets a smile and a chuckle from viewers. What am I doing though? I'm saying, "Hello, Sam. I know that you are a human being just as I am. I like you."

So often, artists keep a distance from their work, but this makes the work dull and cold. Sometimes we use the expression "standoffish." Don't be that. Talk to your work and materials. Your breath is life to them!

A Back of Sam's portrait
B Axle that has moustache on other end (fix with screw)
C Lever (thin material)
D Counterweight
E Free-swinging wire loop
F Flexible wire connector
G Hole through base, support, and lid
H Spindle (skewer)
J Crank
K Handle
L Maple leaf motif (Royal Canadian Mounted Police)
M Heavy base

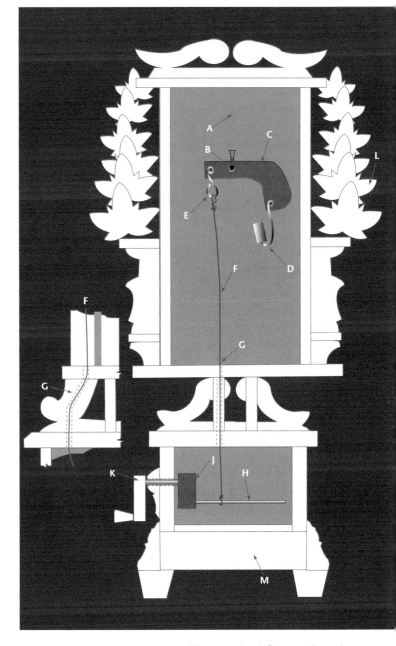

Mystery solved. Once you know how this piece is made, it's fairly simple. A cutaway back view is shown here.

20 Flywheels

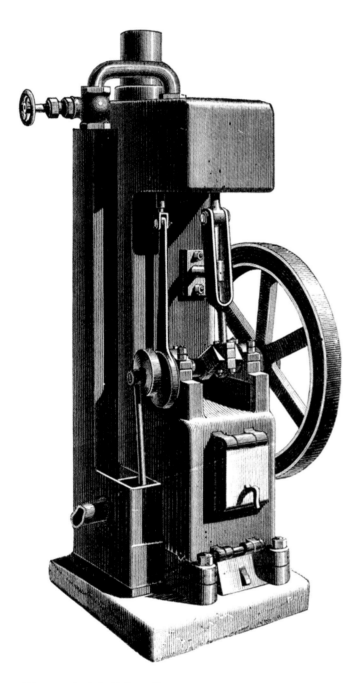

Sometimes we want jerky movement and sometimes we want smooth.

If we can get our toys to run smoothly, this means that the motor or the person winding the handle doesn't have to put extra effort or strain on the machinery.

Kinetic energy is stored in the flywheel. You have to use a little more effort to get things going, but a flywheel has momentum.

Look for flywheels whenever you see old machines—steam traction engines, early two-stroke gasoline engines, and cream separators, for example. Get books on old farm machinery, there are lots, and you'll see them for sure.

We can get a lot of information from looking at old engravings of machinery. On this machine, there is a flywheel, a crank, and an eccentric. Can you find them?

How the Flywheel Works

Take the star machine that you made (back in chapter 17). Instead of winding the handle, push the star stick up and down. By doing this, you can move the handle. Reciprocal movement is changed to circular, or rotary—but there is a problem. When you get to the bottom of the stroke, the crank will be difficult to keep going. It needs a little shove, which is what a flywheel does. The energy stored in the flywheel pushes the crank onward. Circular motion continues.

Momentum

When the cranks and the effort are all in line, there is what is called a *dead point*. Flywheels help, by their momentum, to get past the dead point.

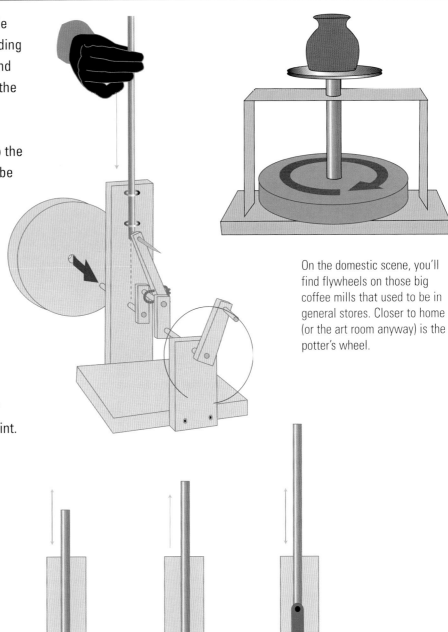

On the domestic scene, you'll find flywheels on those big coffee mills that used to be in general stores. Closer to home (or the art room anyway) is the potter's wheel.

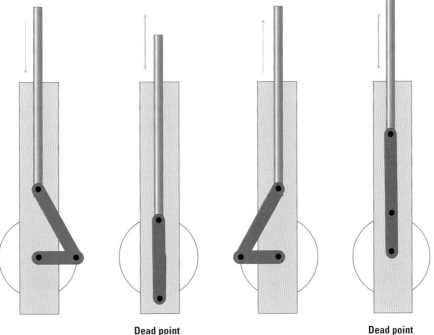

Dead point Dead point

21 Zoetrope

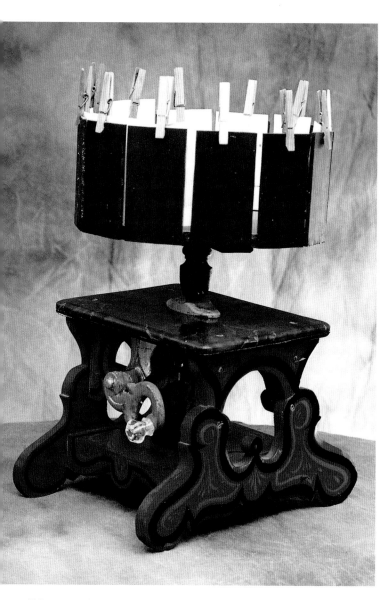

This zoetrope has a fancy stand and drive mechanism. Bevel gears from an old printer were used to achieve the right-angle turn from the handle. Under the drum are two Velcro-covered disks to transfer the power to the main vertical shaft and flywheel.

Movies don't really move. We think they do because our mind tricks us into seeing them that way.

Our eyes (and brain) keep everything we see for a little while, so that when we see something else right after seeing something, the images overlap. This is called persistence of vision.

Movement and Animation

Look at cartoon or comic book characters. When they move fast, what do they have behind them or around them? They have movement lines.

When we look at someone moving fast, we don't see those lines, but we see a blur. Sometimes the cartoon shows a blurred picture of something moving.

Movie cartoons are made by photographing lots of pictures of a thing in slightly different positions. This is called animation. We can build a simple machine to animate our own drawings and pictures. This one is called a zoetrope.

There are many other machines that incorporate simple animation. They have fantastic names such as *phenakistascope* and *praxinoscope* and *thaumatrope*! You will find them in museums and books about antique toys. Look them up; or make one.

How a Zoetrope Works

If we look at a series of pictures, one after the other, in quick succession, we just see a blur.

The zoetrope in the photo has a series of boards around the main disk. There is a space between each board through which we can see the pictures. The blank back of the board separates each picture into its own frame, so we don't see a blur, but the appearance of movement.

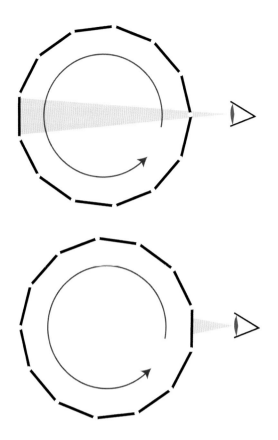

Now you see it—now you don't. As the drum revolves, the eye sees through the slot and then vision is obscured by the black space between cards. Do you remember the flickering effect of old movies? This is what caused it.

In cartooning, we might show a ball dropping just by putting curved lines above it. What we are actually implying are the positions of the ball as it drops.

In animation, each position of the ball is shown in a separate box. These boxes are called **cells**. Here, the ball is falling at the same speed as in cartooning. The blue lines help you to see the different positions of the ball as it drops.

Building Your Zoetrope

This is the size of a standard recipe card. If you can't get this size, you can cut them out of any thin cardboard and they will work just as well. Or you could change the size of the circle to suit your card size.

The radius of the circle will be:

Card width + ¼ inch x 13

3.142 inches

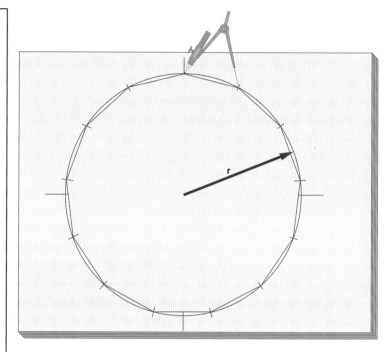

On a sheet of ¾-inch plywood, scribe a circle of approximately 6¾ inches radius. Divide the perimeter into 13 parts. (Set your pair of compasses to approximately 3¼ inches and adjust to fit.) Join the marks to make 13 flats around the circle. Cut it out.

Drill a hole in the center of the plywood (the size will depend on what you use for a spindle). Make 13 pieces of hardboard 3 inches wide and 5¾ inches long. Nail them onto the edge of the plywood flush to the bottom.

Paint the outside of the hardboard with a matte black paint. The cards will be held to the boards with clothespins, or you can experiment using something else. Directions for mounting the drum on a base are below. When everything is assembled, spin the drum with your hand or use an old phonograph turntable. They work really well. Try different speeds.

Mounting the Zoetrope Drum

Put a block in the center of the underside of the plywood to receive the spindle (½-inch dowel is good). Make a base like the one I have suggested. It's very simple but quite sufficient. The holes are a little larger than the dowel. Notice the nail in the end of the dowel to reduce friction. Some lubricant would be good here too. If you put a flywheel on the lower end of the spindle, the drum will revolve a lot easier and smoother.

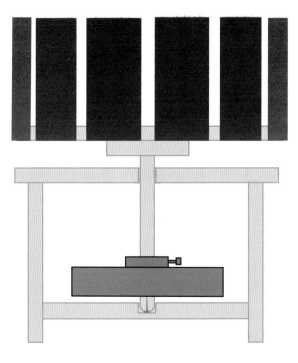

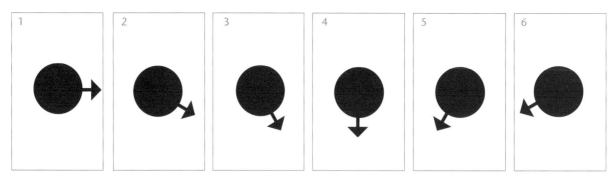

Here are some examples of cards, to give you an idea of sequence. Create your own patterns; have an adventure.

Number your cards before you start. You think you will remember the sequence, but you won't. Trust me!

Colors look different when moving. Some colors seem to just disappear!

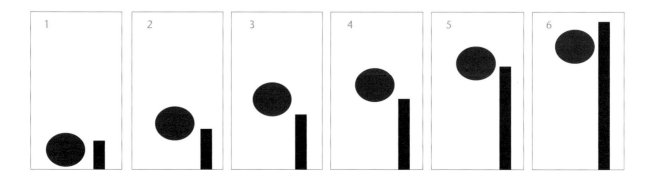

 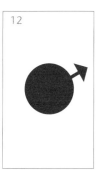 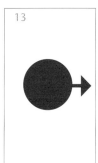

22 | Pulleys

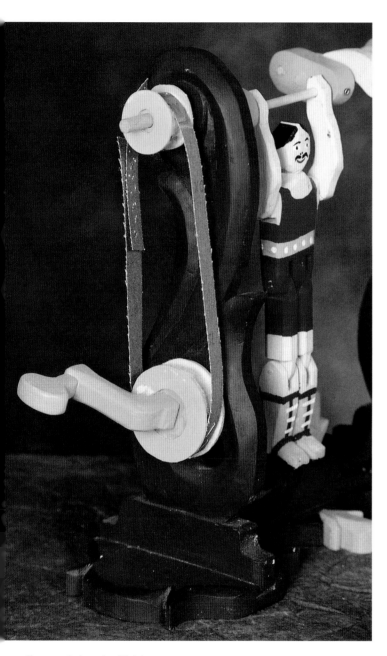

Trapeze Artistes by Al Johnstone.

Transferring power from one shaft to another can be done with a pulley, or two or three.

Not only can we transfer power, but we can also increase or decrease speed and we can change direction.

One pulley is on one shaft, and another pulley is on the other shaft. Belts connect the pulleys and everything goes around! Great stuff, but there is one problem, and it has to do with the belts. Belts can slip, bind, and stretch, which leads to loss of power, machine jams, and erratic movement. Once you get them set, though, it's plain sailing—until they act up again!

Belts can be made of just about anything flexible—leather, cloth, string, elastic, rubber, or plastic, for example. The pulley moves the belt by friction (the enemy of smooth running), another problem.

Problems, problems. On the other hand, if you have to use a pulley and belt to get the movement you want, go for it! For every problem, there is a solution; for every solution, there are problems.

My favorite saying: When one door closes, another one shuts!

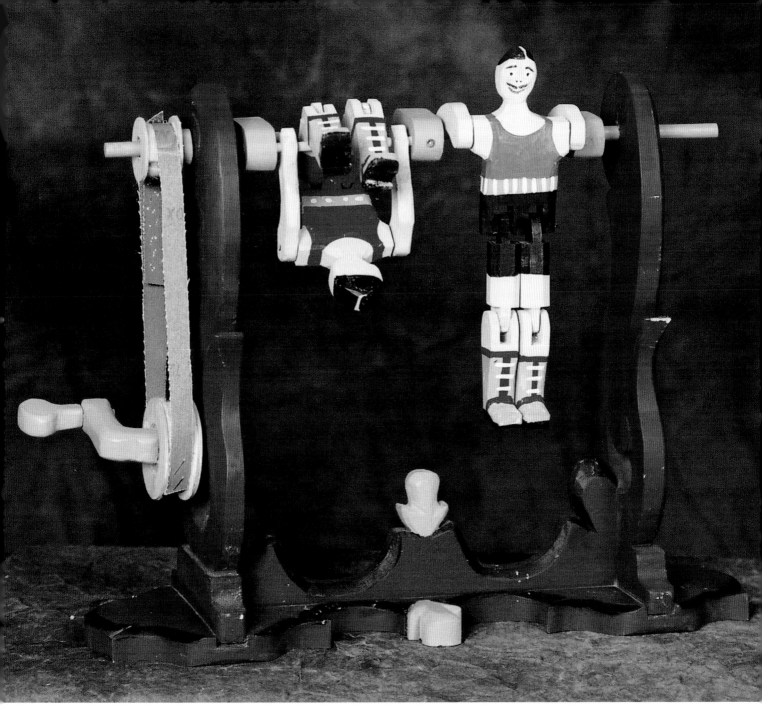

Pulleys in action: Al Johnstone transfers the power from the handle through the pulleys to activate this piece. The pulleys are covered in felt on the contact areas. The belt is a strip of cloth-backed sanding disk. Keep trying until you find the suitable material. It may take a while for you to discover what will work, but don't quit!

Al Johnstone uses a crank handle to get the power from the operator to the toy. He's got a pulley to transfer the power to the main shaft with a ratio of about 1:2. As the handle turns once, the shaft turns twice. The acrobats swing on a crankshaft. Their joints allow them to have plenty of action. The sturdy base is decorative and colorful.

Al Johnstone is a woodworker and generally thoughtful guy. He builds sensible furniture and stuff like this in his saner moments.

Making Pulleys

Pulleys can be made, bought, or found. The old standby of a thread reel is always handy, but you will need some that are different sizes.

Pulleys can be constructed or carved, just like the ones that Al made.

To construct a pulley, take a disk and two pieces of thin board—either hardboard or plywood. Cardboard works well too, as does metal sheet (if that's in your mind and suitable for your toy).

A screw or pin needs to be in the side of the disk to stop it from rotating on the shaft. Glue the three pieces together, or fix them in some way that's suitable to your material. There's your pulley.

Make another pulley the same size, or smaller or larger.

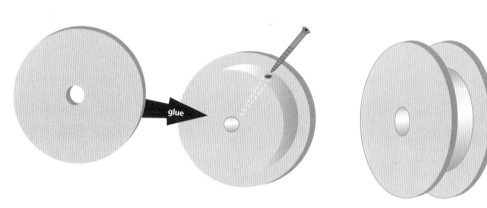

glue

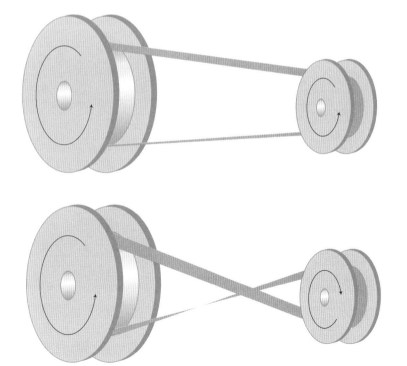

Connecting Pulleys

Pulleys are joined with a belt. The power goes from one to the other. The pulley that has the power is called the *drive pulley*.

The drive pulley can be smaller or larger than the others, or the same size. On the opposite page, you can learn more about this.

When the belt goes from the top of one pulley to the top of the other, the rotation is in the same direction.

If the belt goes from the top of one pulley to the bottom of the other, the rotation is in a different direction. In other words, crossing a belt will give you opposite motion.

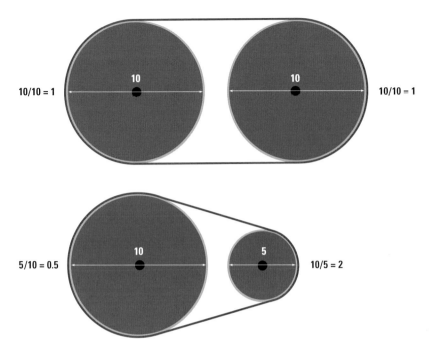

10/10 = 1 10/10 = 1

5/10 = 0.5 10/5 = 2

Power/movement can increase or decrease depending on which pulley is the input and which is the output.

Power and Advantage

Pulleys are similar to levers in some ways. If we have a teeter-totter (a big lever) with people of equal weight and at equal distances, we have equal movement — equal advantage. With pulleys of equal size, the number of revolutions at one end is equal to the number of revolutions at the other. Ten revolutions of one pulley equal ten revolutions of the other.

When one pulley is twice the diameter of the other, it will turn at half the speed of the other. On the other hand, we could say that one will turn at twice the speed of the other. This is kind of tricky to understand, so I recommend that you do a little experiment. Make a model and see for yourself.

Calculations will tell you how many turns each pulley will make according to size.

A really big pulley coupled to a very small pulley can lead to problems because of the limited amount of contact area on the small pulley, which means less friction. But don't let me stop you—try it. Maybe it will work!

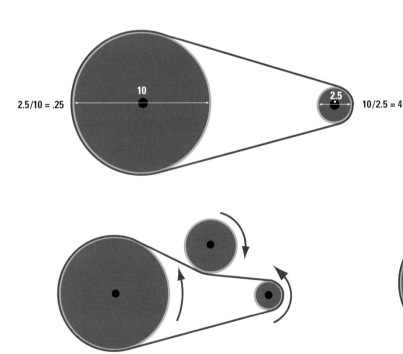

2.5/10 = .25 10/2.5 = 4

Riders will turn in the opposite direction unless they are inside the system.

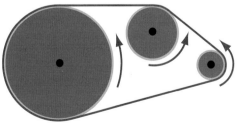

More than two pulleys can run off a belt. They are useful too. There's more about them on the next page.

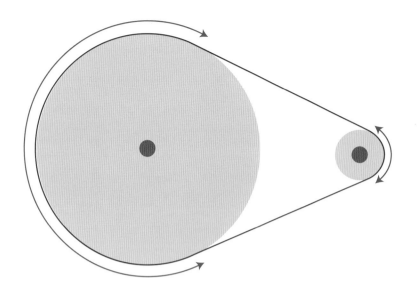

Using Friction to Your Advantage

Friction is not always a bad thing; sometimes we need its help. Belts around pulleys turn the pulley because of friction.

The belt rests on the pulley and moves it with friction. The contact areas in the top diagram are shown with the blue arrows. Notice how the big pulley has more than half its circumference in contact with the belt, which is good, while the small pulley has a smaller proportion touching the belt, meaning less friction and so less drive and maybe even slippage.

There are ways to avoid this. One is to situate the pulleys further apart; another is to put in a rider, sometimes called an *idler*.

To use a rider, we make the belt somewhat longer and then we push the belt in to tighten it.

There are advantages to using a rider. We can use it to turn the power on and off and yet still keep the machine running.

On the opposite page are diagrams of different arrangements of riders.

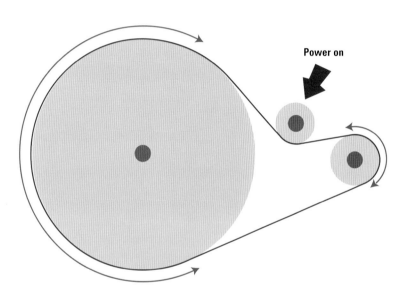

Power on

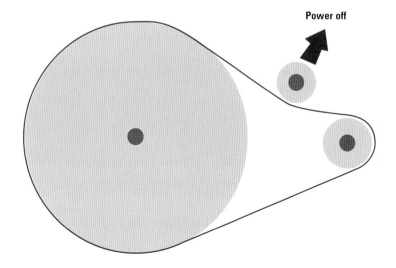

Power off

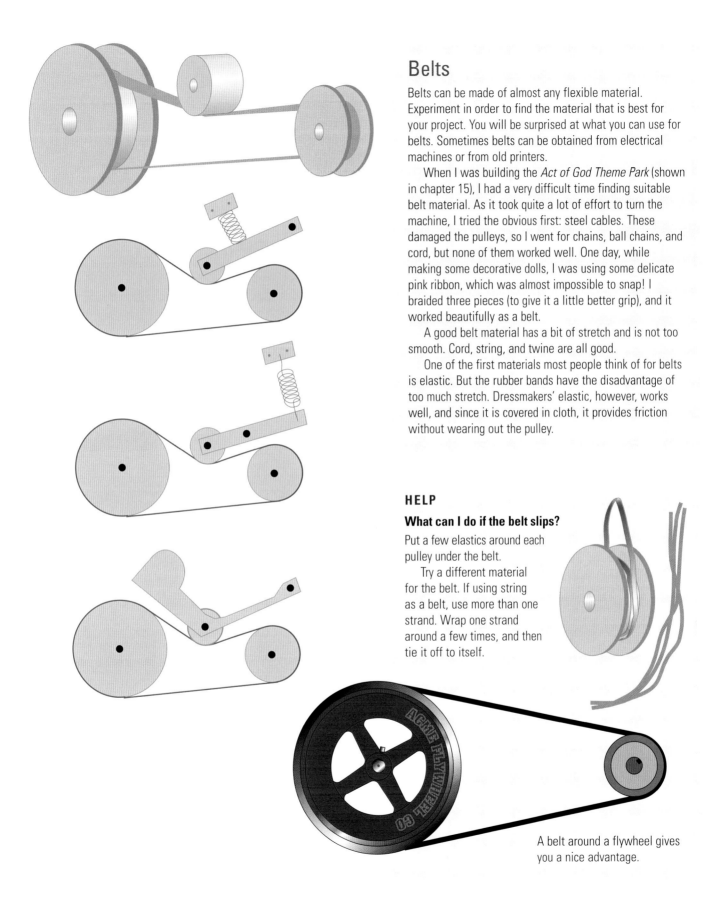

Belts

Belts can be made of almost any flexible material. Experiment in order to find the material that is best for your project. You will be surprised at what you can use for belts. Sometimes belts can be obtained from electrical machines or from old printers.

When I was building the *Act of God Theme Park* (shown in chapter 15), I had a very difficult time finding suitable belt material. As it took quite a lot of effort to turn the machine, I tried the obvious first: steel cables. These damaged the pulleys, so I went for chains, ball chains, and cord, but none of them worked well. One day, while making some decorative dolls, I was using some delicate pink ribbon, which was almost impossible to snap! I braided three pieces (to give it a little better grip), and it worked beautifully as a belt.

A good belt material has a bit of stretch and is not too smooth. Cord, string, and twine are all good.

One of the first materials most people think of for belts is elastic. But the rubber bands have the disadvantage of too much stretch. Dressmakers' elastic, however, works well, and since it is covered in cloth, it provides friction without wearing out the pulley.

HELP

What can I do if the belt slips?

Put a few elastics around each pulley under the belt.

Try a different material for the belt. If using string as a belt, use more than one strand. Wrap one strand around a few times, and then tie it off to itself.

A belt around a flywheel gives you a nice advantage.

23 Sounds

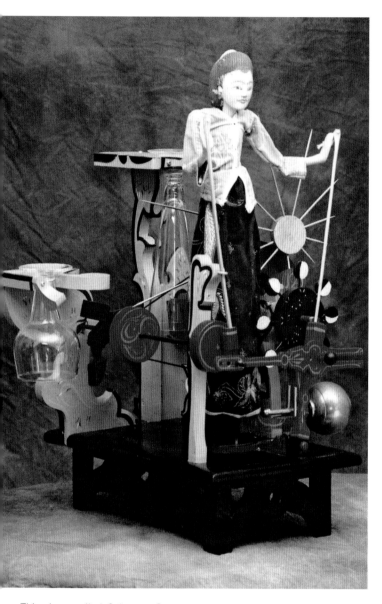

This piece, called *Calmness Serves the Mind,* has two glasses that ring when a bonker hits them. The bonker is painted dark blue and can be seen just to the right of the left-hand glass. It is a part of the blue shaft system.

Mechanical things make noises. If you are lucky enough to have ever been near a steam engine, locomotive, or traction engine, you will remember that one of the main delights is the sound—the whirring, clanking, and chugging that it makes. If you were lucky enough to hear two engines, you will know that—each one has its own sound.

We are used to hearing machines make sounds, and this is one way we have of knowing whether or not the machine or kinetic art is working. A silent machine worries us. For example, when a computer, after being asked to do something, seems to just sit there, we get concerned. Is the machine dead? We listen for some sign of life.

HELP

My machine sounds like it's in pain. It squeaks, squeals, and groans—is this OK?

Sounds tell you about the working of your piece. Squeaks and groans are different from a good healthy knocking and ticking. Parts that squeak and groan do not want to move in the direction that we intend, and they are having a hard time doing so. Squeaks and groans use up power. They are caused by friction, and friction makes movement difficult. But it is actually helpful when we hear squeaks and groans, since we know where to lubricate and/or adjust the mechanisms. As the old saying goes, it's the squeaky wheel that gets the grease.

Movement and Sound

Movement and sound go together. Kinetic art—well, anyway, the stuff that I do—has its own sound. I never know what that sound is going to be. The sound is a discovery and a bonus. I love it!

Although machines make sounds all by themselves, you can create your own deliberate sounds in many ways. Here are some to get you going.

Clicking Sounds

Ratchets and cogs acting with levers and trip hammers produce a click-click sound. Shown here are large teeth. This is not the only shape or size of teeth. Smaller ones make different sounds than bigger ones.

Faster speeds cause higher-pitched sounds.

Finding Sounds

Glasses and kitchen utensils all have their own sound. Tap gently to test.

Finding sounds is part of the everyday experience of kinetic art. Take a pencil (the one I know you always have handy for jotting down ideas) and rap it lightly on the object. What makes a good sound—a tight grip on the pencil or a loose one?

Experiment and remember.

With an action lever, you can get both movement and sound.

Chimes

The bonker (what would *you* call it?) can help produce some nice melodic chimes.

Here is how the bonker works. Rotation of the shaft brings the free-swinging end up and around, causing it to drop onto your chimes.

Drill a hole in an open mortise and insert a stick into it, and swing the tenoned bonker on it. Note the larger hole in the tenon.

Rotation of the shaft brings the free-swinging end up and around, causing it to drop onto your chime.

Put two or three in a machine to create a wonderful sound. Include some in a wind-powered whirligig, and drive the neighbors crazy!

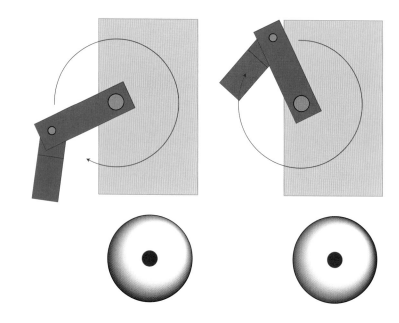

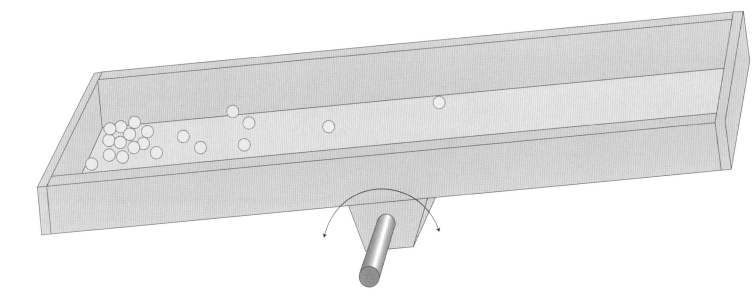

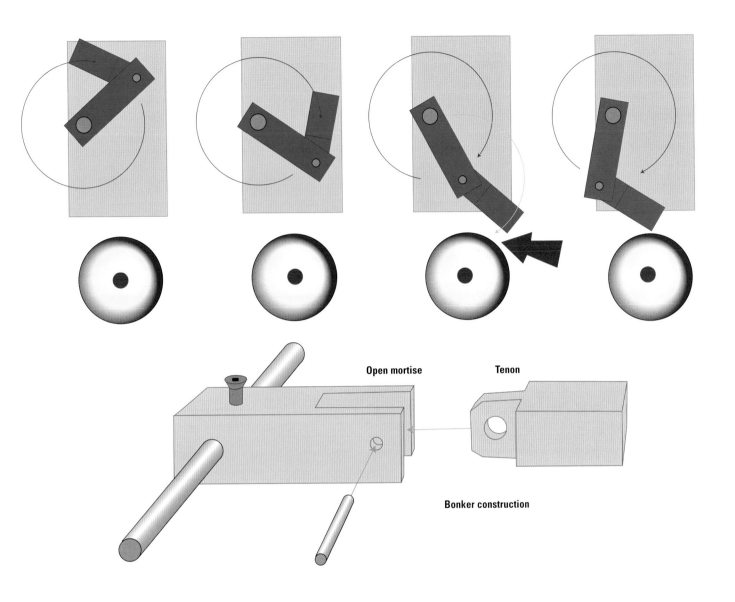

Open mortise **Tenon**

Bonker construction

Creating a Wave Machine

For a *wave machine*, beads or small ball bearings roll around in a box or tin, making the sound that you hear at the beach. I leave it to you to figure out how to incorporate this into your machine. Up-and-down, gentle motion is needed. How do you create that?

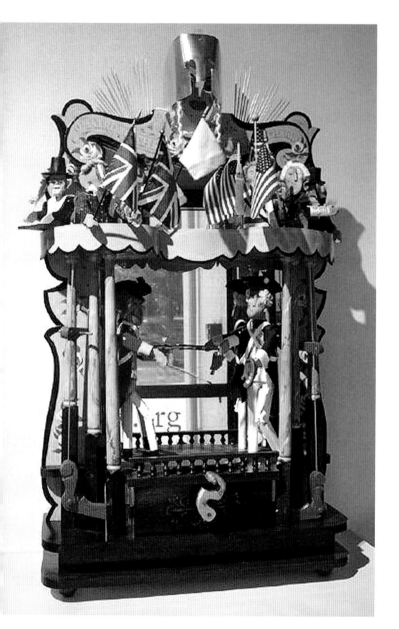

From a Lovely Mother Comes a Beautiful Daughter. Athena is the goddess of war and art. I made this piece to explore her strangely opposing responsibilities. The house I was working in was built by a man who had been with George Washington at Valley Forge, so I based my theme on the American Revolution. After about three weeks of work, I realized that the soldiers should be fencing with brushes and have palettes for shields; so that's what I gave them.

A bstract art is interesting, but sooner or later you just have to put in some figures to get the point across to yourself and others. Figures, however, can be abstract too. Look at Marcel Duchamp's celebrated painting *Nude Descending a Staircase*. It is almost kinetic. Those who put things in compartments will say it's cubist, but you can look that up for yourself. While we're on the subject, have you noticed how one thing is leading to another here as we do this work? Everything is connected.

Returning to our figures, it can be said that people add interest and expression to kinetic art.

We can recognize a person from the simplest of figures, so our models don't have to be very detailed to give the effect of a living body and convince viewers that they are looking at a human form.

A Simple Figure

A simple jointed doll can be made like the one in this drawing. Al Johnstone's acrobats, in chapter 22, for example, are made this way. Notice that some of the holes for the dowel are large and some are small. This is to help the movement. Put in as much detail, either by carving or painting, as you need to convey your idea.

Don't let anyone stop you from putting two and two together and coming up with five or six. Say "What if?" and then get going to find out.

Will you find the answer? No, you will find that there are many answers—pick one, two, or three, or as many as you need!

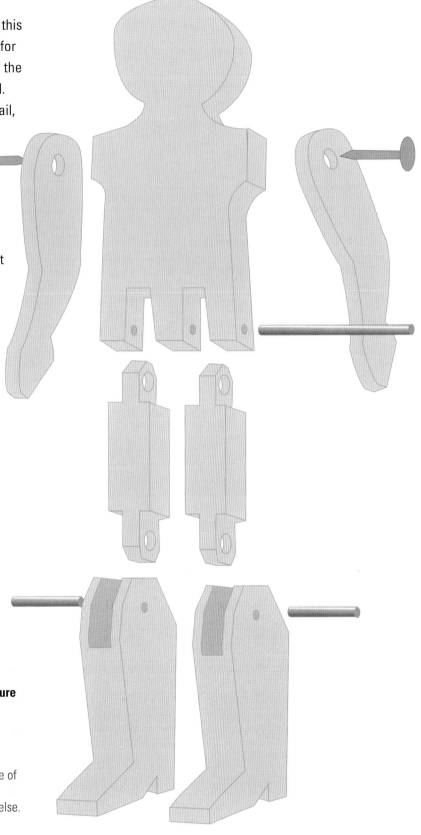

HELP

How will I know how much detail to put into my figure to make it look like a person?

Start making the figure, and when it begins to look like a figure instead of a piece of wood, stop.

When is something a piece of wood and when is it something else? This is a mystery. Metamorphosis is one of the wonderful things about making things—about art. It starts out as one thing, and then it becomes something else.

Bringing Simple Figures to Life

Figures in kinetic art soon make the viewers forget that they are looking at a machine. When playing the street (busking) with my toys, I often hear mothers say to their kids, "We're leaving now. Say good-bye to the man." But to whom do the kids say good-bye? Not to me—I don't exist. They say good-bye to the dolls!

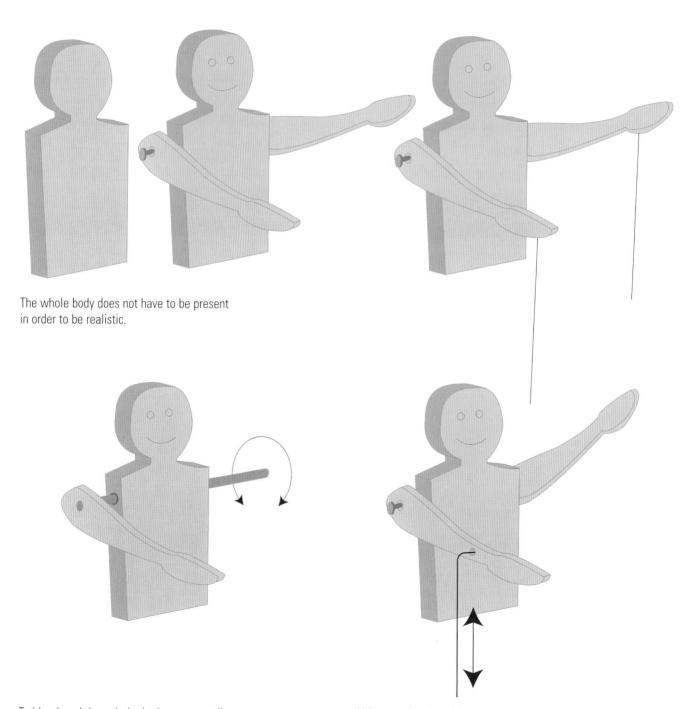

The whole body does not have to be present in order to be realistic.

Twirl a dowel through the body or some adjacent part.

Wires can be placed for good leverage.

Here are some ways to bring simple pieces of wood to life. Wires, strings, and rods can be used to move arms, legs, and the body in different ways. You will think of other means of moving parts, but these will get you going.

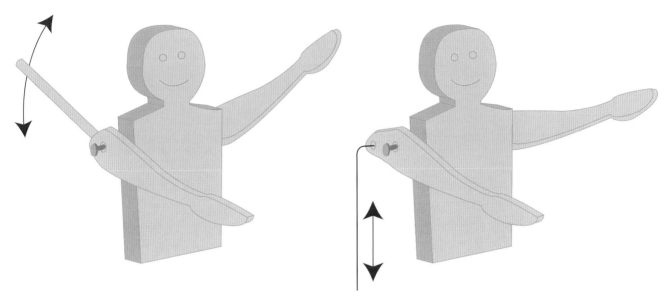

Although we like to see the machine and how it works, a lot of the enjoyment comes from the secret moves the piece makes. Paint can disguise and camouflage wires and rods.

Rods and wire move these arms.

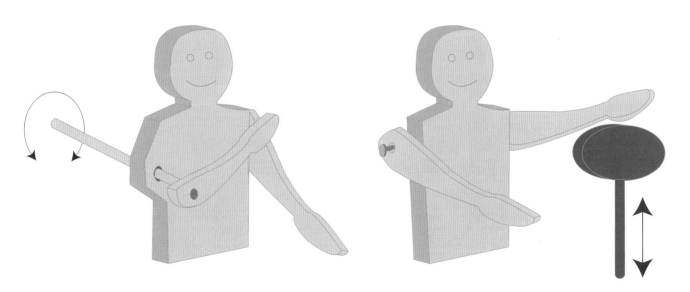

Round and round for crazy effects or to and fro for strumming.

Some other piece of the machine can nudge body parts into motion.

Persons

Who would think that a ball on a stick could be a person? This little guy is called just that in a catalog of project parts that I have.

Creatively though, these units don't necessarily have to be used as people. They can be used in any direction and for whatever we imagine would solve our problem.

They are great for distant crowd scenes or small people close up. Use them in a game for counters. Individually, they can be moved with sticks and wires, just like you can move any other piece of wood.

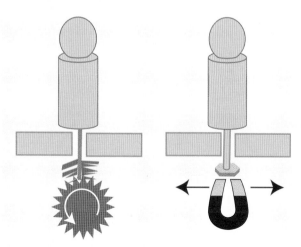

Jostling and slight movements can be done with magnets, levers, feathers—you name it.

Body Shapes

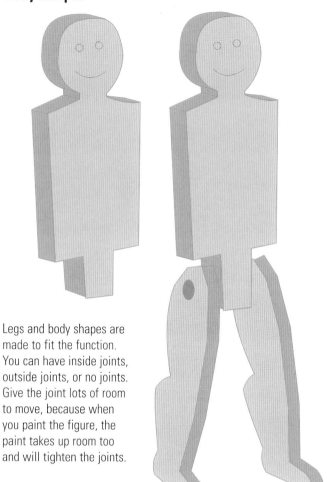

Legs and body shapes are made to fit the function. You can have inside joints, outside joints, or no joints. Give the joint lots of room to move, because when you paint the figure, the paint takes up room too and will tighten the joints.

HELP

After I painted the figure, I found that joints that had moved freely became very tight. Why did this happen and what should I do?

Paint types such as acrylics have a water base. Water swells the wood and makes dowels fatter. Also, paint has a thickness and it gets in and on things, making the joints tight and the motion stiff.

After the paint is dry:
- For holes, take a drill of the same size as the original hole and carefully ream out the accumulation of paint or swelled wood.
- Dowels and axles may need a sanding with some fine sandpaper.
- Wood-on-wood lubricates itself but paint-on-paint doesn't. Put in a little grease.

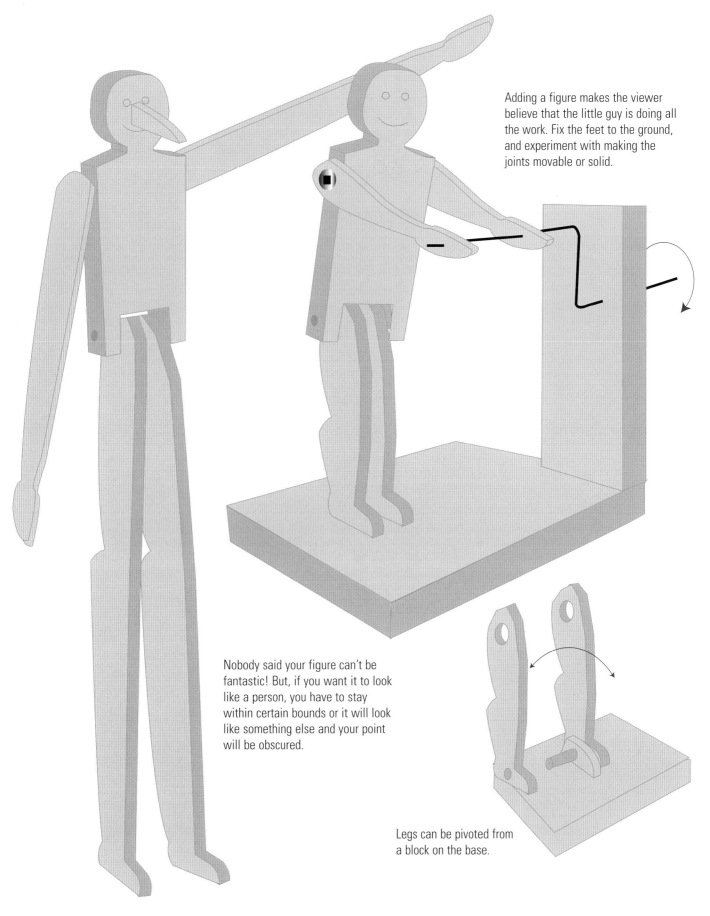

Adding a figure makes the viewer believe that the little guy is doing all the work. Fix the feet to the ground, and experiment with making the joints movable or solid.

Nobody said your figure can't be fantastic! But, if you want it to look like a person, you have to stay within certain bounds or it will look like something else and your point will be obscured.

Legs can be pivoted from a block on the base.

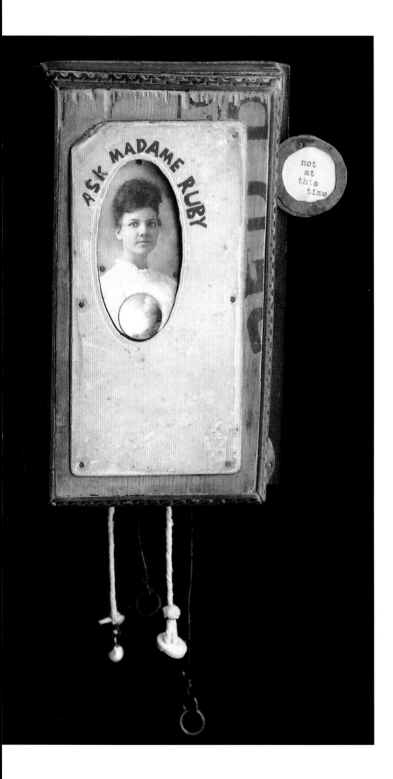

Ask Madame Ruby by Kevin Titzer. The box in the actual piece is about 8 inches tall. The piece helps one make decisions. Which string shall I pull to find my answer? Do I act upon her advice? Is she correct? She looks nice—why would she lie?

Did I ever say talk to your work? I think I did. When you talk to your work, you help it come alive. Actually, you don't have to say the words out loud—just think them. (After a while, you will be able to think without words.)

Kevin Titzer has taken this one stage further and made a fortune-telling machine that we can talk (or think) to. *Ask Madame Ruby* is a little machine that looks as if it was found in a frontier ghost town. It's made of old pieces of wood, cardboard, string, nails, a bit of nice frame molding, and a photograph, which anyone could find and put together.

How *Ruby* Works

The strings, each with its own identifying end, are attached to levers. On the outside end of each lever is a disk with a message. The levers are pivoted on spindles that run from the front board to the back board. The levers are kept in position, front to back, with tubing that is slipped onto the spindles.

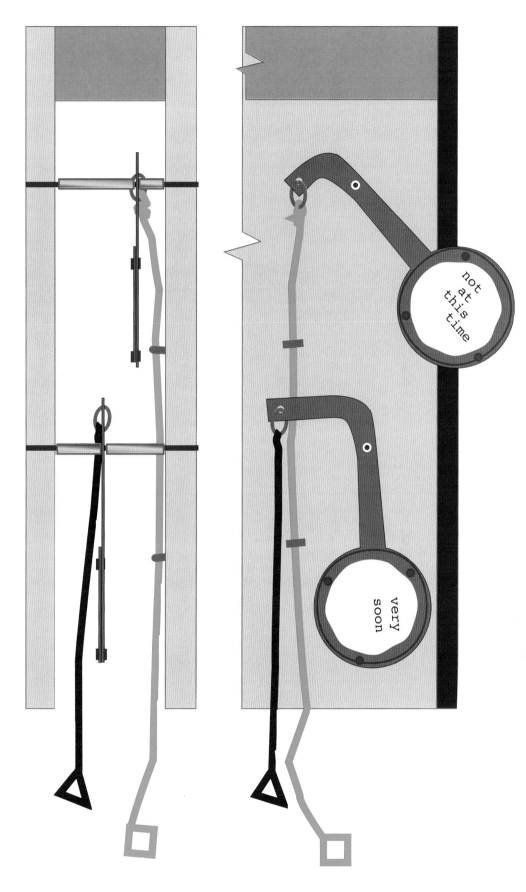

Kevin Titzer, who made *Ruby*, lives in Evansville, Indiana. Right now, he's making dolls and figures from driftwood that he collects by the river. By the time you read this, who knows what he will be making.

2 + 2 = 5 or Red?

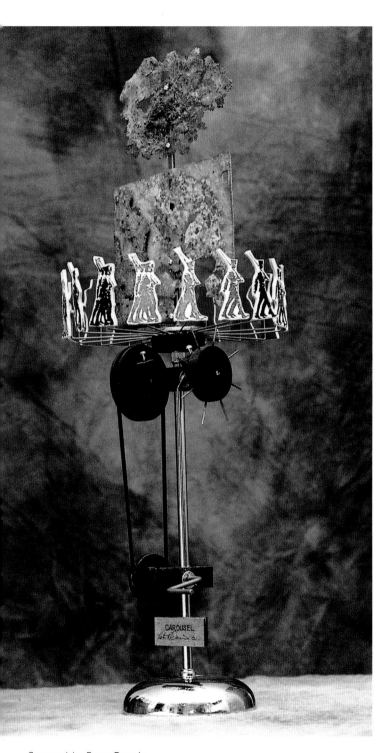

Carousel, by Peter Dennis.

Putting two things together, we come up with something else. When we hit the glass with a pencil, we got a sound. When we put paper in the straws, we got a vane. Sometimes we don't know what we are going to get, and we make a discovery. Ideas are formed this way. Be ready to receive them. Don't gag and find some reason to reject them.

Working at kinetic art, we make discoveries all the time. The material may remind us of something—something that is similar or something that may not even be perceived by the same sense.

The Idea for *Carousel*

Two pieces of rusty metal got Peter Dennis thinking about soldiers, 1914–1918 soldiers, marching, senselessly going around in circles, unable to get off the carousel of events, and doing what they are told to do. Maybe we are all like that sometimes. We wonder why we keep doing certain things that may not be in our best interest yet we keep doing them—and all these thoughts from just two bits of rusty iron!

The main and most important feature of this sculpture is the spider cog wheel that makes the soldiers go around and around. Details of this and other good stuff are on the next page.

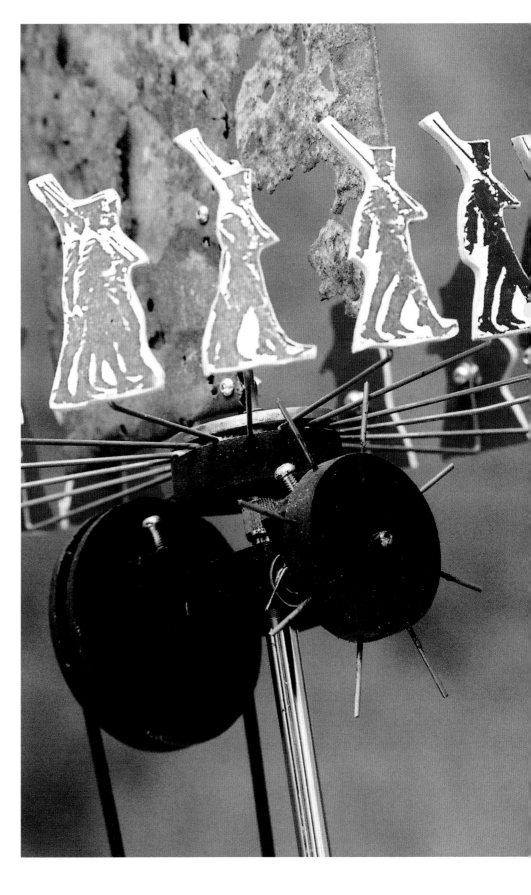

How It's Made

Carousel uses a pulley system to move the soldiers around and around. The soldiers, though, are going around horizontally—that is, at right angles to the pulleys. To get this effect, Peter has used a spider gear.

The belt on the pulleys is made of dressmakers' elastic. Get it cut to the length you need. Butt-glue and then sew the ends together for a nice belt. The cotton covering gives a nice finish and helps to provide a little friction. Plain elastics or elastic bands are generally not good for this kind of work. They are difficult to use and control, they have short lives (they perish), and they break.

Notice how the stand on this piece is quite small. What effect would this have on the stability of the piece, particularly when winding? Do you think this is deliberate?

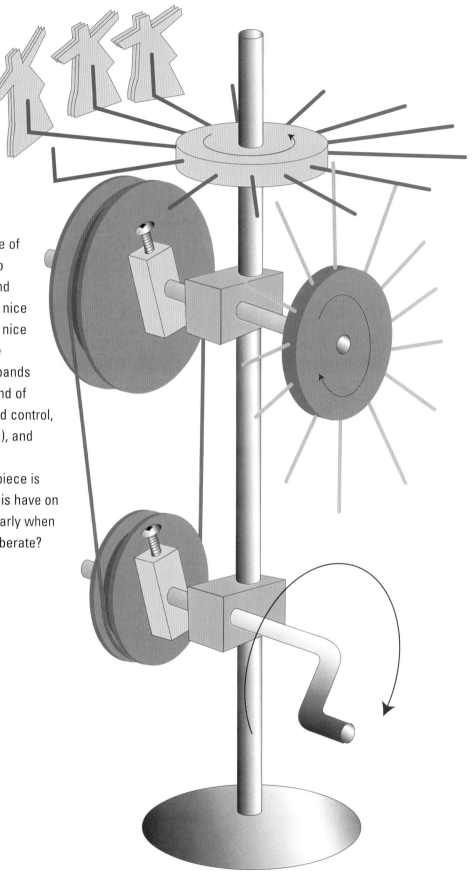

Making Spider Gears

Spider gears are made by drilling holes around the perimeter of a disk and inserting wires. Accuracy is needed here, or they will give you problems, such as jamming and missing.

This spider gear has 12 spokes, but you could try any number.

Saw cuts around a disk hold the spokes. The spokes can be made of stiff or flexible material. Pieces of credit cards work really well.

Gears

Gears and cogwheels are difficult to make because you have to be very accurate. However, they can be bought as parts of toys and games. Find a toy that has them and contact the manufacturer. The gears are often sold as separate items.

Gears work on the same principle as do levers and pulleys.

A cog with 40 teeth engaging another with 40 teeth will produce equal revolutions. Forty teeth working with 20 teeth means that the 20-toothed cog will turn twice for every turn of the 40-toothed cog.

You can make simple gears for simple pieces or experiments by wrapping and gluing corrugated paper around lids from jars. Try different sizes and see what happens.

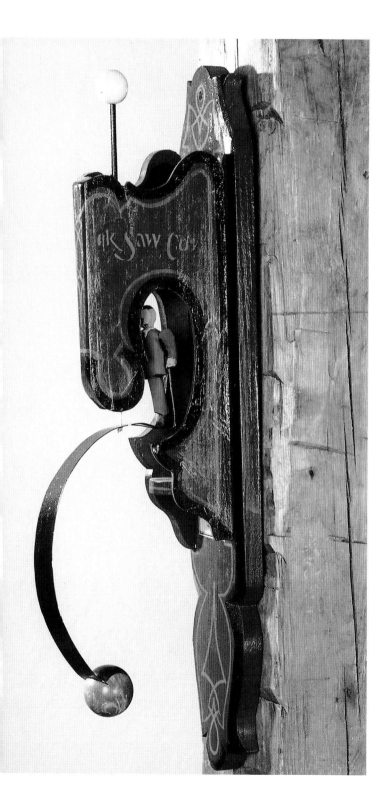

Slow movement is good; it gives us quiet times. With slow changes, as with the seasons and the weather, we can see our kinetic art pieces changing, getting older, mellowing, maturing.

Wind is a force that will move our pieces, and weather is a force that will change them. Wet weather makes materials expand, and dry weather makes things contract. You will discover this as you build your kinetic art. Sometimes something will stick and then later it will work again—the weather could be the cause.

Once I was showing a large number of my machines at an outdoor event, when suddenly a thunderstorm blew in. There was no way I could cover everything up, and all the machines were drenched! Everything that was made of wood expanded and stuck solid.

I took the whole mess home to my workshop and waited and hoped. Every day I tried gently to see if they would work again. About a week later, the wood was back to its original shape and movement resumed!

The Résumé uses at least two kinetic systems. One is balance; the other is twisting catgut, which is really bull's intestines. OK, yuck! But what else could you use?

The Weather-House Idea

I came up with this idea when I was experimenting with balancing toys. I wanted the connecting piece, between the counterweight and the object, to be a part of the art instead of just a stick or piece of wire. At that time, I was also interested in a one-legged-man theme.

I made the connector the shadow. The counterweight was the world with the shadow cast over it. Then I thought of the weather-house theme, and here it is.

During and after the First World War, men of the British army who had been wounded and were convalescing wore a blue suit and a white shirt with a red tie. Everyone knew that they had been wounded.

How it Works

The ball and stick at the top wedge the catgut into a hole. You will need this adjusting device to move your figure into position.

Old-time catgut is twisted-up cord made from animal intestines. When it gets damp, it untwists a little. When it dries, it twists back. This is the basis for this weather-house toy.

Nowadays, it's hard to find a supplier of gut strings because violinists don't like using this material for the very reason that we do—it twists and turns as the weather changes. But if you can get hold of an old tennis racket, you'll have a lifetime supply.

To whom it may concern

To find out which side the little guy comes out for expected wet weather and which for dry, apply some steam from a kettle. The side from which he exits is the side for wet weather.

28 | Gravity

One force that is always with us is gravity. Often it slows things down and kind of gets in the way, but some kinetic artists use gravity to activate their ideas. Craig Bloodgood makes giant pachinko machines powered by gravity.

Gravity-driven machines and amusements have been around for a long time. Maybe you had one as a kid, playing in the bathtub—you can still get them. You pour water in the top, and it runs out of a hole and drives a paddle wheel. We don't think of them as machines that utilize gravity as a propelling force, but that's what they are.

Clock by Craig Bloodgood. The problem with using gravity is that it works in only one direction. The ball has to get back up to the top. This clock uses an electric motor to bring the ball up on a conveyor to the top runway. Then it rolls down and drops, activating the mechanism. The ball then leaves on the lower runway and goes back to the conveyor for another go-round.

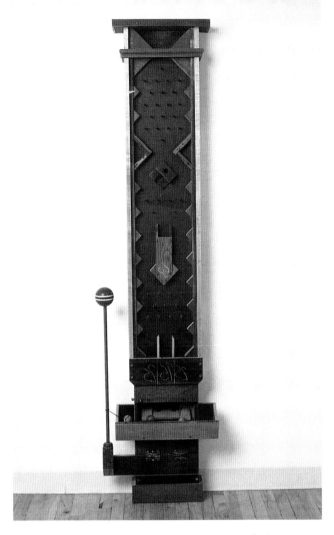

Pachinko Machines by Craig Bloodgood. These giant pachinko machines have you bring the ball up to the top.

Craig Bloodgood is the Special Projects Curator at the Art Complex Museum in Duxbury, Massachusetts. He says, "Expose the workin's of the machine; there is art there!"

The Idea of Using Gravity

During Victorian times, and into the twentieth century, toys were made with big hoppers on top. The hopper was filled (by you) with sand, and the sand trickled down, turning a miniature paddle wheel. The wheel was connected to cranks and levers that activated pictures and scenes. Look in some books about antique toys to find some.

With Craig's machines, you put a ball in the top and it powers itself down by gravity. An interesting bonus is the time that the ball takes to reach the bottom.

Egg timers and the hourglass use gravity. Clocks can be driven this way too. Can you figure out a way to do that? Craig Bloodgood did!

29 | What if?

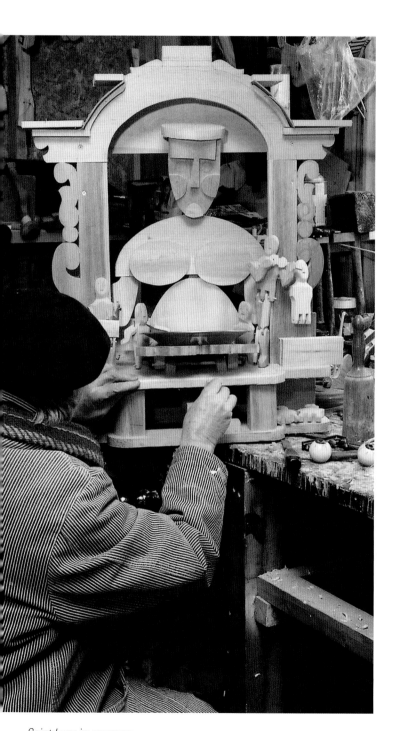

Saint Lucy, in progress.

Now we have come almost to the end of this book. It's a short book and I've only been able to give a smattering of all the mechanical wonders that are yours for the making when you get involved with Kinetic Art. When I was getting this book together, I showed it to some friends and they said "but this is not just about art, it's about physics and math and science as well." They were right. They pointed out one of the most exciting things about being an artist—particularly kinetic artists—there are no boundaries for us. We are problem solvers, thinkers; we ask the artist's question—**What if?** Then we try to solve it.

Here's a typical **What if?** Of mine.

There are a lot of artists in my family and I sometimes wonder why this is, when most families have bankers or car mechanics or shop workers.

My great grandmother's name was Lucy and I got to thinking the artist's main thought—**What if?** I wondered "what if" maybe my Grandma Lucy was really Saint Lucy, the goddess of light and perception? So I started making this piece. It's about my family and Grandma Lucy being the giver and mother of us all. I'm still working on it, as you can see.

You might wonder where I get some of my ideas; people often ask me that. Ideas come from putting things next to each other and you need a lot of things in your stockpile.

The way I do it is this—I get interested in just about everything that comes my way! Looking at everything and wondering how it works. I do a lot of reading too. Reading and looking at books is an important tool/skill for the artist. I don't read the words; I look at the pictures, unless I'm not sure of what's happening in the picture. I always try to have some picture book to look at. I look at dancers, buildings, and boats; I look at everything just like a kid does. This is where I get the information that turns itself into knowledge. If you do this, you too will have a great fund of stuff in your brain to choose from that you can use in your art. You will get a good sense of history and styles, images of diverse nature— religious/musical, machinery, weapons, face, modes, stories, myths, cultures—all kinds of interesting things. Put some of them together and ask—**What if?**

Saint Lucy is always shown in church images with her eyeballs on a plate, which she holds out in front of her. Here is the plate and the eyeballs. When you turn the handle, the plate tilts and the eyes go round and round on the plate!

METRIC EQUIVALENTS

inches	mm	cm
⅛	3	0.3
¼	6	0.6
⅜	10	1.0
½	13	1.3
⅝	16	1.6
¾	19	1.9
⅞	22	2.2
1	25	2.5
1¼	32	3.2
1½	38	3.8
1¾	44	4.4
2	51	5.1
2½	64	6.4
3	76	7.6
3½	89	8.9
4	102	10.2
4½	114	11.4
5	127	12.7
6	152	15.2
7	178	17.8
8	203	20.3
9	229	22.9
10	254	25.4
11	279	27.9
12	305	30.5
13	330	33.0
14	356	35.6
15	381	38.1
16	406	40.6
17	432	43.2
18	457	45.7
19	483	48.3

inches	mm	cm
20	508	50.8
21	533	53.3
22	559	55.9
23	584	58.4
24	610	61.0
25	635	63.5
26	660	66.0
27	686	68.6
28	711	71.1
29	737	73.7
30	762	76.2
31	787	78.7
32	813	81.3
33	838	83.8
34	864	86.4
35	889	88.9
36	914	91.4
37	940	94.0
38	965	96.5
39	991	99.1
40	1016	101.6
41	1041	104.1
42	1067	106.7
43	1092	109.2
44	1118	111.8
45	1143	114.3
46	1168	116.8
47	1194	119.4
48	1219	121.9
49	1245	124.5
50	1270	127.0

Conversion Factors

1 mm	=	0.039 inch
1 m	=	3.28 feet
1 m²	=	10.8 square feet
1 inch	=	25.4 mm
1 foot	=	304.8 mm
1 square foot	=	0.09 m²
mm	=	millimeter
cm	=	centimeter
m	=	meter
m²	=	square meter

INDEX

ABOUT THE AUTHOR

Rodney Frost is a graduate of Brighton College of Art, who holds a National Diploma in Design and a teaching certificate from the University of London. He taught for several years before combining his technical knowledge (he attended a building and engineering school for five years) with his aesthetic abilities, designing tableware and bottles for the glass industry.

Moving to Northern Ontario in the early seventies, he resumed his teaching career. His art background and interest in Native culture led him to develop Native art studies programs at Wasse Abin College and various reserve schools.

The qualities inherent in the Native culture awakened in him an interest in his English heritage, and he founded *Stocks' Hill Wagon Works* to build and restore horse-drawn vehicles. He has also created other businesses, including *The Grim Reaper Mechanical Toy Company,* and appeared on Canadian TV promoting low-tech woodworking.

Other books he has written include: *The Nature of Woodworking: The Quiet Pleasures of Crafting by Hand* and *Making Mad Toys & Mechanical Marvels in Wood,* both published by Sterling.

A craftsman, creator, and communicator, Rodney has shared his knowledge at colleges, schools, and community centers over the past forty years. He is currently working in Ontario, making kinetic art and other woodworking projects and developing new forms of whirligigs based on traditional folk art models.